Aesthetics for Young People

Edited by Ronald Moore
University of Washington

A Cooperative Effort among the
American Society for Aesthetics
The Journal of Aesthetic Education
and the National Art Education
Association
1995

The essays in this book originally appeared in the *Journal of Aesthetic Education*, volume 28, number 3, fall 1994. Reprinted by the National Art Education Association, 1916 Association Drive, Reston, Virginia 22091-1590, by arrangement with the University of Illinois Press, 1325 South Oak Street, Champaign, Illinois 61820

About NAEA . . .
Founded in 1947, the National Art Education Association is the largest professional art education association in the world. Membership includes elementary and secondary teachers, art administrators, museum educators, arts council staff, and university professors from throughout the United States and sixty-six foreign countries. NAEA's mission is to advance art education through professional development, service, advancement of knowledge, and leadership.

ISBN 0-937652-73-3

Contents

Introduction

This collection of essays addresses the topic of aesthetic instruction for children. In one sense, the topic seems extremely easy, for young people have from time immemorial been taught the aesthetic perspectives and values characteristic of their cultures in a host of familiar and ordinary ways. In another sense, however, it seems very difficult, for the philosophical theories that aim to make sense of these values and perspectives are quite forbidding. It is hard to see how aesthetics as a philosophical enterprise can be imported into the precollege classroom; yet it is evident that the potent and intriguing themes aestheticians explore should be reflected on by youngsters at all stages of their development. The contributors to this collection confront these problems in a variety of ways, drawing upon a rich diversity of scholarly and practical experience. What unites their essays is a common commitment to the intrinsic importance and contemporary educational applicability of their subject.

This collection is especially timely for three reasons. First, it appears at a moment when the effects of various art education reform programs are being felt and assessed nationwide. These programs—the Getty DBAE project, Project Zero, Arts Propel, the California Arts Project, and several others—have had a dramatic impact on the way in which art is presented in the nation's schools. Many, perhaps most, of these efforts have been marked by continual struggle to find the right way to incorporate an aesthetics component into educational plans. Second, this collection arrives in the midst of heated debate over the place aesthetics should occupy in the National Standards for Education in the Arts, as jointly crafted by the members of the Consortium of National Arts Education Associations. In this important standards document, aesthetics has been relegated to a problematic supporting role, integrated with, but by no means as prominent as, the other arts-related disciplines. And third, the publication of this collection follows closely upon the formation of the first Standing Committee on Aesthetics for Children by the American Society for Aesthetics, the national professional association for philosophy of art. The creation of this committee ushers in a new awareness on the part of the nation's aestheticians of aesthetics' potential precollegiate impact. Several contributors to this collection are charter members of the committee.

The essays are arranged in an order meant to be conducive to sequential reading. Generally speaking, the earlier essays deal with foundational concepts, the later ones with specific applications of these concepts, both in and out of classrooms. While all the essays are self-contained studies of their subjects, each crosses wires with several of the others. To emphasize the interconnection of the ideas in play, essays drawn from a single discipline (philosophy, art education, psychology, museology) are alternated rather than grouped with others.

An introductory essay by Ronald Moore establishes the context of contemporary debate over the role of aesthetics in the development of young minds. Moore identifies three charges that must be rebutted if efforts to integrate aesthetics into school curricula are to succeed: that aesthetics is exclusively a grown-up enterprise; that it is extraneous to (standard) art education; and that its subject matter is too difficult for school children. In answering these charges, Moore introduces strands of analysis that are developed at greater length in the subsequent essays. Marcia Eaton provides several ingredients essential to coherent discussion of this topic: a definition of philosophical aesthetics, an account of the nature of aesthetic experience, an analysis of the way in which various aesthetic elements fit in with other elements of art education, and an assessment of certain limits on aesthetic education. Eaton's essay is especially valuable in its measured approach to the difficulties of conducting aesthetic training in a multicultural context. Michael Parsons takes up the question of what developmental aspects there may be in learning aesthetics. He argues that children think about art in characteristic ways at various stages of cognitive development and that they form what amount to implicit philosophies of art as they proceed. Parsons's analysis suggests that children's ability to appreciate art intelligently is closely linked to their ability to think philosophically, a conclusion strongly supportive of aesthetics' place in the classroom.

In these three essays, as in the others in this collection, aesthetic experience figures prominently as a topic and objective of aesthetic education. Anita Silvers challenges this concept, or at least the elevated role purely aesthetic experience (the so-called "innocent eye") has assumed in modern times. She argues that detached experiences of art are fictitious and that therefore contextualism, recognizing the full repertory of cultural baggage and other learned background information, is inevitably more important in art than is usually recognized. This is a view affirmed in Ellen Handler Spitz's essay, particularly as it involves psychosocial and emotional features of children's aesthetic environment. In scrutinizing two experimental programs for elementary school children, Spitz makes a case for respecting both the children's developmental imperatives and their need to engage unexpected and unplanned-for experiences.

Similarly drawing on a stock of successful classroom results, Marilyn Stewart provides a clearheaded and useful plan for the incorporation of aesthetics into the K-12 curriculum. Her essay sets out program rationales, identifiable learning goals, and detailed instructional strategies. Even in the presence of such good advice, teachers are sometimes intimidated by the prospect of teaching children aesthetics. Margaret Battin's essay presents a philosophically honed technique specially designed to defuse teacher anxiety and facilitate learning, the "Case Method." This method, capitalizing on young people's native fascination with puzzles and posers, involves student engagement with various (real or hypothetical) fact-vignettes, chosen to train attention on key problems in aesthetics. Battin's essay includes a sample of "cases" illustrating this approach.

Of course, the aesthetic education of children is not limited to the classroom. One setting in which it frequently takes place is the art museum. Katherine Walsh-Piper investigates the role museums may play in producing conditions conducive to the aesthetic experience of young visitors. She points out the special opportunities museums provide in setting objects aside and thus transforming them into context-dependent foci of appreciation. Like Stewart's, Walsh-Piper's essay is well stocked with detailed practical suggestions to the aesthetic educator. And finally, Cynthia Rostankowski points to another often extracurricular, often overlooked locus of early aesthetic education, home learning connected with alphabet books. She maintains that children's alphabet learning is importantly enhanced and facilitated by the aesthetic experience these humble volumes engender. It is edifying to observe in this tightly focused essay the persistence of many of the same philosophic issues have been ventilated by its more sweeping predecessors.

The editor and contributors wish to acknowledge the support and encouragement Ralph A. Smith has given to this project. No individual has done more over the years to advance the cause of aesthetic education in America than Professor Smith, longstanding editor of the *Journal of Aesthetic Education*. This collection aims to collaborate in that cause by presenting new research on the role of aesthetics in the lives of its youngest subjects.

Ronald Moore
University of Washington

Aesthetics for Young People: Problems and Prospects

RONALD MOORE

> The major players on the arts education scene can be likened to the members of a newly formed string quartet. No matter how skilled each of the players may be individually, successful performance as an ensemble remains a formidable challenge. While realizing their individual parts properly, the players must learn to listen to one another, to pick up subtle cues of timing, attack, phrasing, etc., to arrive at the same—or at least concordant—interpretations of a piece and to blend these in a performance which makes sense not only to the players themselves, but also to their wider audience.

> —Howard Gardner

Three important truths are woven together in Gardner's characteristically perceptive trope.[1] First is the encouraging fact that now, as never before, diverse players—schoolteachers, college professors, administrators, artists, critics, art historians, aestheticians, and others—are combining their talents and techniques in an effort to strengthen American art education. The new quartet has been formed. Second is the discouraging fact that these parties, like those in any new ensemble, are having difficulty achieving harmony. The various players have differing roles and ranges of performance. They know how their instruments work separately, but they are only now discovering how they will work together. They don't yet have a common ear. And third is the practical truth that their own judgments as to what works best will not be the final arbiter of their success. In electing to play together, these parties have accepted the challenge of making what they produce sound right to an audience of students, parents, state officials, deans, and so on. These latter folks want more than harmony; they want a certain kind of harmony. Dissatisfied with both the boring routine of old standards and the trendy esotericism of the avant garde, they insist on something of each, or something in between. Above

Ronald Moore is Associate Professor of Philosophy at the University of Washington. He is a frequent contributor to the *Journal of Aesthetics and Art Criticism*, a coauthor of *Puzzles about Art*, and the author of articles in *Ethics*, *Philosophy East and West*, and *Nomos*.

all, they want what they hear to be intelligible, engaging, and pleasant. Yet these are all qualities on which players are just as apt to differ among themselves as to differ with their audiences. The fourfold internal problem of achieving harmony is thus multiply compounded, and the task facing the new quartet formidable indeed. This collection of essays addresses one of the stiffest challenges facing those who have undertaken to redesign American art education. It is the task of making philosophical aesthetics accessible and useful to young people. This is a concern that, although centered in the classroom, extends far beyond it to the museum, the theater, the concert hall, and ultimately to every setting conducive to aesthetic experience. For aesthetics is more than the philosophy of art; it is the philosophical study of the nature and components of all experience we identify as aesthetic.[2] Because such experience may occur in most reaches of a person's life, beginning in childhood, we should expect that the consequences of introducing young people to aesthetics will be pervasive and longlasting. The rationale for introducing aesthetic subject matter into school curricula is not to be understood as merely the enhancement of art education; rather, it sets the stage for critical reflection, redirected awareness, and heightened appreciation as these pertain to an extraordinarily broad range of objects. Even when aesthetics and philosophy of art are taken as synonyms, it should be understood that the art in question is the art of living no less than it is the art of gallery walls.

Still, if American youngsters are to be introduced to aesthetics, it will almost certainly be in school that this happens. And the usual agent of introduction will be the art teacher. Typically this instructor will be overworked, undercompensated, adequately trained in some of the arts (most commonly the visual arts), and altogether unacquainted with philosophical aesthetics. It may seem wildly impractical, to say nothing of unjust, to impose on this teacher the additional burden of mastering an exotic field of study familiar to few outside philosophy departments, finding ways of inserting parts of it into an already crowded (and probably rigidly constructed) curriculum, then inventing techniques for interesting young pupils in the new material. But, the situation need not be as bleak as it seems. For one thing, the great preponderance of contemporary aesthetic writing does concern art, with the greatest share going to the visual arts. So there is a shared stock of referents on which to build. For another, the philosophic issues that arise in respect to art fairly epitomize the wider issues of aesthetics and enjoy the great advantage of ample historical development. So the art teacher can focus on the familiar without fear of missing the main contours of the wider discipline. And finally, various philosophers have recently undertaken to prize the truly important issues in aesthetics free from their obscure theoretical matrices in the expectation that they may be presented in forms both art teachers and students can fathom and enjoy.

Being satisfied that a thing can be done is one thing; being satisfied that it should be is another. We may be prepared to concede that, with training, effort, and imagination, K-12 teachers are quite capable of incorporating aesthetics into their art curricula and yet remain unconvinced that it would be appropriate to do so. In the continuing debate over whether current collaborative trends in American art education are salubrious, three groups of skeptics have emerged. First, some people are convinced that aesthetics is the kind of discipline that is conceived by, written for, and appropriately directed to, adults exclusively. These skeptics regard the introduction of aesthetic subject matter into elementary education as forced and phoney pedanticism, something on the order of teaching uncomprehending kindergartners a smattering of Latin verse to recite on Parents' Day. Second, there are others who are equally convinced that, although there is nothing peculiarly adult about the field of aesthetics, it is too disconnected from the core concerns of art education to be anything but intrusive and confusing. They regard it as meretricious in the way instruction in herbal history would be to a cooking class. And third, there are those who simply regard aesthetics as too hard for youngsters. Without denying that the field is pertinent and potentially useful to young people, these skeptics deny that there is any means by which this reach of philosophy can meaningfully be communicated to precollege students. It will be worthwhile to take each of these questions up in turn.

Is Aesthetics an Adult Enterprise?

Two kinds of arguments are made in support of the claim that aesthetics is of its very nature an adult enterprise and hence inappropriate for children. The first is an historical argument aiming to show that it always, or almost always, has been so; the second is a conceptual argument aiming to show that it cannot be otherwise. The latter kind of argument inevitably becomes tangled with skeptical claims of the third kind (viz., that aesthetics is too hard for children) and can be postponed to the place where these claims are taken up. It will suffice at this point to consider the historical argument.

There is no denying that, both recently and historically, most writing generated by professional aestheticians has been directed to adults—admittedly much of it to other adult professional aestheticians. And in this body of writing, the focus of attention has persistently been on adult experience, adult sensibilities, adult questions. But these facts cannot alone settle the question of whether the ideas at work in such writing are available and applicable to children. It is easy to suppose that the seriocomic, say, is something only a grownup can fully understand; but how can the adult grow to understand it without wrestling with the tumultuous questions of identity, affect, and transmutation that typify adolescent experience? How,

in general, can one become an aesthetic adult except by preparing the way in childhood?

The history of Western philosophy is, in fact, replete with testimony on the importance of young people's exposure to admixtures of artistic, literary, and philosophic ideas in readying them for enlightened adulthood. Just as students must reflect on the fundamental principles of science, politics, history, and so on, if they are fully to understand these disciplines and their role in the life of the state, so must they reflect on the fundamental principles of the arts to understand how these enterprises unite the life of the state with that of the individual. A smattering of training in art or art history is never regarded as a mark of genuine cultivation. Rather, the dominant view has always been that artistic products must be seen and thought of in a context of theory to be truly edifying. Framed by the philosophical imagination, they must be captured by the mind as much as by the senses.

Plato's notorious strictures on artistic practice in *Republic* Book X are balanced by his insistence in Books II, III, and VII that education in several of the arts (music, drama, poetry, literature) is essential in the early education of leaders.[3] The arts, as he conceives them, are charming in themselves, but more importantly are useful in freeing young minds from their instinctive infatuation with material things, thus clearing the way for attention to ideas, the Forms themselves. Not only does he regard the arts as propaedeutic to the ruling mentality; Plato regards ruling itself as an art, one that capitalizes on the affinity between excellence of form and goodness of nature, and whose characteristic virtue, justice, is as much an aesthetic as it is an ethical notion. The educational program suggested by this fusion of philosophical and artistic enterprise was developed and refined by later Platonists, ultimately achieving its most dramatic ascendancy in Ficino's Florentine Academy. The Italian Renaissance was, in a general way, a grand experiment in the viability of Plato's ideas. The monumental artistic achievements of this period were built on a solid foundation of theory. And the theory dealt not merely with the principles of technical practice, but with harmonies between them and the wider principles of social life. It was during this period that the fine and decorative arts were incorporated into what became known as the "liberal arts," curricula designed to liberate young minds by exposing them to the conditions of moral and social nobility.

However much Enlightenment thinkers rebelled against the conventional wisdom of entrenched Platonism, they more often than not endorsed the theory of aesthetic education that lay at its core. Arts were still regarded as liberating, inspiring, and, above all, conducive to the inculcation of philosophical thought in the young. This view is evident even in that most iconoclastic of educational manuals, Rousseau's *Emile*. Although, like Plato, Rousseau has no end of disparaging things to say about the social evils the arts foster, he reserves a prominent place for them in the nurture of children's natural talents. There are important new elements here: Rousseau

warns against intrusive zeal in the artistic training of young people[4] and insists on empirical observation as the basis of fitting the educational program to the child. But the main thrust of Rousseau's views on art education is entirely consistent with the tradition he scorned. Young Emile is portrayed as learning the arts to complement and amplify his learning of the sciences and logic, doing so by uniting the love bred by the arts with the interest inspired by the other disciplines. In this way, Rousseau argued, young people may be led to employ their full emotive and cognitive capacities in enjoyment of the truths that, proof against the corrupting influence of civilization, make life healthy and whole.

It is with Kant that systematic aesthetics really begins.[5] Kant read Rousseau's *Emile* and was powerfully affected by it.[6] But we do not see in the work of this college professor and lifelong bachelor any explicit concern for the role of philosophy and art in early education. Kant was absorbed with the question of what conditions must obtain in order for a person to be a fully rational, autonomous adult. He taught, spoke to, and wrote for grownups; still, he appreciated as few have before or since the importance of evolving social consciousness in making young people ready to become grownups. In one of the following essays, Michael Parsons, a leading developmental art education theorist, accepts the challenge of considering what Kant never got around to addressing: the question of how one comes to be an aesthetic adult.

Human development and the evolution of various forms of experience were issues about which many early twentieth-century aestheticians concerned themselves. Foremost among them was John Dewey, whose work brought education and aesthetics together with unprecedented power. It never occurred to Dewey that aesthetics might be an adult enterprise, because he took both art and aesthetic experience to be salient articulations of the natural, continual development of whole lives. At the stage of childhood, he observed, there is no firm distinction to be drawn between work and play; and when the two flow together in a particularly rewarding way, we call the result art.[7] At the stage of adulthood, the consummatory quality that vests things in general with value articulates full patterns of experience, drawing infancy, youth, and maturity together into intelligible wholes. It is hardly surprising that in all of Dewey's voluminous writings, there is no explicit discussion of the prospect of introducing aesthetics as a subject in (precollege) schools. As Dewey saw it, aesthetics was already there; it had to be. Children on a playground, in coming to appreciate the special joys of baseball and its many subtly interwoven elements, become as directly aware of an aesthetic dimension of life as children drilled in the "masters" of artistic tradition.[8]

As will be evident from even this cursory historical review, the many philosophers and educators who today urge the introduction of aesthetics into America's art education curricula can hardly be charged with radical

innovation in deeming the subject suitable for young minds. They are instead but complementing and extending a venerable philosophical tradition, giving it a modern voice and style. And the joint verdict of the old and new thinkers is that art, reflection on the meaning and importance of art, and reflection on art's lessons with regard to wider aesthetic experience are not merely adult concerns; they are equally important to the young. The historical evidence does not show that aesthetics is an exclusively adult enterprise.

Is Aesthetics Extraneous to Art Education?

The second group of skeptics maintain that philosophy of art is so different from the other allied disciplines in art education that efforts to fit it in with the others are bound to be awkward and counterproductive. They insist that early education in art has a foundational core, concentric spheres of ancillary studies surrounding it, and a penumbra of diminishing relevance beyond. Studio art—into which may be gathered music, dance, drama, even literary composition, as well drawing, painting, sculpture, photography, and so on—is unquestionably at the heart of the enterprise, because children need direct experience with artistic practice if they are to understand anything more about art. Art history, art criticism, the technology of art, creative psychology, and so on, are disciplines that, by consensus, occupy spheres reasonably close to the core. The skeptics hold that aesthetics, together with such disciplines as museology, metacriticism, the sociology of patronage, the science of restoration, art law, and so on, are sufficiently penumbral to make it unproductive to commit classroom time to them prior to postsecondary studies. The art teacher, it is argued, cannot be expected to teach everything, core through penumbra; and the effort to do so buys expansiveness at cost to the subject's central concerns.

No doubt part of the appeal of this position is a widespread popular mistrust of philosophy in the schools no matter what its focus, a mistrust infecting teachers as well as parents and schoolchildren. It is no less difficult to convince some art teachers that their young artists-in-training need to know elements of philosophy of art than it is to convince watchmakers that they need to know something about the philosophy of time. On this broader front, however, there is now ample and convincing counterevidence. For many years now, at sites around the nation, efforts to bring philosophy into the K-12 classroom have met with success far outstripping initial expectations. The leading force behind these efforts has been The Institute for the Advancement of Philosophy for Children, at Montclair State College. This institute, founded in 1969 by Matthew Lipman and directed by him since, has produced a substantial body of empirical evidence to go with its theoretic claims as to the philosophical educability of school-

children. More importantly, the many teachers trained at the institute have reported striking student receptiveness and general "spinoff" benefits as a result of incorporating philosophical materials in their curricula. Lipman and his colleagues repeatedly stress the point that the main purpose of their philosophy for children program is to help youngsters learn how to think for themselves, carefully, reflectively, and critically—no matter what the topic.[9]

Still, it might be argued, the evidence that children can profitably learn philosophy in the classroom doesn't, by itself, show that philosophy of art can be a profitable part of art education. For one thing, Lipman's institute has not made aesthetics a major focus of its pedagogical program.[10] For another, some of the standard "straight thinking" and moral problems issues used to introduce philosophy to schoolchildren are easier to grasp and more apparently practical in their implications than standard issues in philosophy of art.

Dramatic evidence that aesthetics *can* succeed in the art classroom and that it can be effectively integrated with the central elements of art education has recently been generated from a number of sources. Most prominent of these nationally are the Discipline-Based Art Education project (DBAE), sponsored by the Getty Center for Education in the Arts,[11] and Project Zero, founded at Harvard University by Howard Gardner. Others include the Kettering Project at Stanford University, the Aesthetic Education Project at the Central Midwestern Regional Education Laboratory, the California Arts Project, as well as numerous regional and local endeavors. The common thread that runs among these diverse programs is a perception that aesthetics asserts its worth not by competing with the other art disciplines, but by exploring the meaning and value of their ingredients and interrelations. Even if aesthetics is traditionally relegated to the disciplinary margin, its gravitational influence can be felt in all parts of the system. For it is through aesthetics that the questions get asked, the controversies raised, and the values assessed that elevate the business of the arts from production and delectation to a thoughtful, influential force affecting and being affected by the rest of life.

The argument for the indispensability of aesthetics in an integrated arts curriculum turns on the simple fact that many of the most important issues posed by the other disciplines are themselves philosophical. As young artists experiment with new materials and new artforms, they inevitably encounter the question of what makes a thing art, the fundamental definitional issue in aesthetics. As young musicians consider what interpretation should shape their performance, they face the age-old philosophical issues of creativity and fidelity. As young readers ask themselves whether a book means just what its author meant by it, or perhaps more, they are already engaged with problems of textual integrity and authorial intent that are

among the liveliest in modern philosophy of literature. Fakes and forgeries
fascinate kids and foster speculation about authenticity and originality.
Works from other cultures raise questions about how much we depend on
our own background to understand what we perceive. Ugly, troubling, and
polemical pieces propel young minds across disciplinary borders to con-
front the relations of aesthetic and other values—political, religious, moral,
and so on.

It would be pointless to try to introduce art history into an art program
without involving it with the philosophical subjects art history entails. Art-
historical evidence might, for example, go a good way toward showing
whether a given portrait is complimentary or insulting to its subject; and a
prominent issue in aesthetics (the phenomenon of "aspection") arises as
soon as the student raises the question of whether it could be both. Again,
art-historical evidence might reveal that prior to a certain date some fea-
tures of the aesthetic environment (mountains, say) were regarded one
way, and that after that date, they were regarded in another. This observa-
tion (which might have a substantial bearing on the way in which students
look at artworks) is tightly coupled to the aesthetic question as to whether
the features in question might not have been beautiful, say, both before and
after the date in question, although that beauty went unnoticed. Or is beauty
just a subjective quality "in the eye of the beholder" that doesn't exist until
experienced? Far from its being an imposition to consider such issues in an
art course that includes art history, it would be forced and unnatural to
exclude them.

Similarly, if art criticism is to be incorporated in art education, it is hard
to see how the philosophy of criticism could reasonably be omitted. When
the critic regards a particular work as dainty, dumpy, sublime, erotic, offen-
sive, great, and so forth, the aesthetician raises the underlying issue of what
it means to say of artworks that they are any of these things. As art critics
work with particulars, the challenging hard evidence of works, collections,
oeuvres, and the like, they must, in doing so, work from or assume (even if
unreflectively) theories as to what artistic meaning, value, relevance, and so
on, consist in. By introducing aesthetics into a criticism curriculum compo-
nent, a teacher is doing no more than raising for explicit consideration what
is implicit in the subject.

The same point might equally be made for other elements arrayed be-
tween the core and the penumbra. In general, philosophy of art doesn't
have to be imported; it can hardly be kept out. The questions young people
are likely to ask about art provoke the very questions aesthetic theory is de-
signed to answer. One prominent present-day aesthetic theory, the Institu-
tional Theory, takes the bold position that the familiar distinction between
art and the philosophy of art is lost in our time.[12] To the degree this theory
correctly captures the modern art world, it simply confirms the view that

aesthetics is inextricably interwoven with the other elements of art education. The collapse of art theory into art (and vice versa) entails the fusion of all those enterprises that reflect on art with art itself.

It should not be overlooked, in this context, that the philosophy of art can effectively connect art with other areas of the school curriculum. In raising issues in the way it does, aesthetics connects art with general instruction in critical thinking, composition, the sciences of perception and cognition, and all areas of instruction that deal with the contest of values. Nelson Goodman's leading principle in the theory that led to Project Zero, Arts Propel, and the various programs these projects have spawned is that philosophy's place in every enterprise is to improve reasoning.[13] Marcia Eaton has argued that aesthetic value and moral value have a closer affinity than has been traditionally realized.[14] Recent consideration of the putative rights of artworks and the prospects of social constraints on public artworks have led many young students to engage issues in legal, social, and political philosophy as they relate to art.

Perhaps the best evidence that aesthetics integrates well with the various other elements of art education is found in the *Curriculum Sampler* produced by the Getty Center for Education in the Arts to support its Discipline-Based Art Education project.[15] This volume contains eight thematically organized curriculum units written by teachers at the elementary, middle, and high school levels. Each unit incorporates lesson materials from all four of the primary art disciplines (as the Getty project conceives them), productive art, art history, art criticism, and aesthetics. The unmistakable virtue of the collection is that the various disciplinary materials play into each other in an unforced, natural manner, a fact that showed up conspicuously in the field-testing to which all curricula were subjected. The aesthetics materials in particular seem well chosen for their respective age groups, and complement the other materials effectively. The best proof that aesthetics can be integrated into art education is the practical demonstration that it has been.

Is Aesthetics Too Hard for Children?

The final skeptical claim is that aesthetics is just too difficult for schoolchildren. This is a view that receives substantial corroboration in the college aesthetics courses art teachers sometimes take. Like much of philosophy, aesthetics is often demanding, technical, complex, and wrapped in the coils of abstruse theory. It is not surprising that K-12 teachers are antagonistic toward, or phobic about, the field. A single taste of Hegel, Croce, or Heidegger on art is sufficient to convince the average reader that these materials should be kept out of the hands of children.

Undeniably, aesthetics can be difficult; but it needn't be so difficult as to make it inaccessible to young people. And more importantly, it should be

observed that a subject's being moderately difficult need not count decisively against its being incorporated into art education. In his well-known 1984 study of American schooling, *A Place Called School*, John Goodlad reports that students at all levels consistently rated their instruction in arts as easy and relatively unimportant. The discouraging impression Goodlad got of arts programs in the schools studied was that "they go little beyond coloring, polishing, and playing."[16] There is ample evidence that schoolchildren, let alone their parents, want and expect more of art education than this.

The first step in identifying suitable ways to present aesthetic subject matter to schoolchildren is the coordination of instruction with the students' stages of cognitive and emotive development. There is no point in dwelling on the corrigibility of expert interpretation, for example, before students are capable of understanding why some interpretations are regarded as especially telling, and why their corrigibility should be an issue. But recent studies confirm the perception, held by many art teachers and parents, that children of almost all ages have remarkable, unplumbed capacities for responding to art thoughtfully. Perhaps the best of these studies is Michael Parsons's *How We Understand Art*, a work that focuses on children's acquaintance with visual arts, but whose theory and conclusions transfer convincingly to other genres.[17] Parsons's study traces the evolution in young people of aesthetic responsiveness, identifying stages through which this responsiveness characteristically moves and connections between it and other ways of knowing. It thus provides an enormously useful guide to teachers concerned to find the right level at which to pitch aesthetic instruction.[18] Ralph Smith has shown how an ambitious program of aesthetic learning aimed at teaching art as a humanities discipline can be linked to "phases of aesthetic learning" along lines similar to those of Parsons: the ultimate objective of the intelligent, comprehending appreciation of art is to be achieved by the student's passing through phases of exploration and familiarization, perceptual training, historical awareness, exemplar appreciation, and, finally, critical analysis, each tuned to the general level of student learning and development.[19]

Once the appropriate level of presentation is identified, the teacher must find ways of delivering the subject matter that challenges students to think and respond, rather than simply absorb and record information. Like every other area of philosophy, aesthetics demands engagement with the contest of ideas—ideas weighed and tested against each other in a continuing reflective dialogue. It won't do, therefore, to introduce the philosophical element in an art class by interspersing asides about what Plato, Kant, Goodman, and others thought about things into an otherwise production-directed lesson. Instead, the teacher must engage the thinking of the students by inducing them to size up inherently controversial issues and take stands.

The teacher might offer alternative views, invite yet more views from other students, and so on, until the discussion widens to a point where the students themselves are eager to weigh the evidence in favor of this or that position. The truly philosophical elements in art invite dialogue, critical reflection, give-and-take, and conceptual exploration. But these capacities needn't be separately cultivated; they may be educed naturally in the course of discussing the underlying questions that crop up inevitably as young people think about art: What makes something an artwork (at all)? What makes it a valuable or meaningful work? Does the meaning of a work change over time? Is aesthetic value purely subjective? Can things be both beautiful and bad, beautiful and immoral, beautiful and ugly? And so on.[20]

By far the simplest way of stimulating reflection on philosophical issues at most levels of instruction is the so-called "case method," employing puzzles and posers to capture the curiosity and imagination of students while freeing the truly important issues from the atmosphere of learned theory. In this approach, students are presented with a problem consisting of a set of real or hypothetical facts and invited to think and talk about it, with an eye to conclusions ("verdicts") that might be drawn. If the case is well formulated, the puzzle quality, the curiosity factor wrings further questions out of the facts, and these questions lead to other questions, and so on. Altering the question as originally formulated, or the case as stated, by varying one element or another to bring out additional issues challenges students to reflect on the reasons behind their answers. And of course the student answers themselves will provoke "appeals," leading to further questions and further answers, much in the manner of courtroom drama. As a rule, young people are eager to get caught up in and address good, thought-provoking puzzles, so this approach has met with a warm response and considerable success as applied at most K-12 levels. Margaret Battin's essay provides a detailed account of the "case method" approach to aesthetics instruction.[21]

The nationwide effort to incorporate nontraditional materials in art education has fostered various other instructional strategies for teaching aesthetics, together with methods for their evaluation. Many of these are very promising, and several have been successfully field-tested. Marilyn Stewart's essay describes several such techniques developed in professional development workshops on teaching aesthetics and subsequently put into classroom practice. A very useful handbook for the teacher interested in designing a curriculum with aesthetics in mind (as well as for administrators seeking to evaluate such curricula) is *Aesthetics: Issues and Inquiry*, written by E. Louis Lankford, and produced by the National Art Education Association as part of a series promoting a comprehensive approach to art learning.[22] Lankford's book frames the pedagogical issues in clear, down-to-earth terms and provides very important guidance on such important

practical matters as dealing with planned uncertainty, managing classroom dialogue, making good use of student diversity, questioning strategies, examinations, and so on. The devil, they say, is in the details; and clearly such matters as these will count every bit as much as the larger theoretical questions in conducing to the success of aesthetic education for children.[23] There seems to be no doubt in the minds of the teachers who have actually tried out these pedagogical ideas that young people at many stages of development are fully capable of learning from aesthetic instruction, and that art education in general is improved by encouraging them to do so.

Conclusion

If the performers in Howard Gardner's art-ed quartet are ever to make beautiful music together, aesthetics must be brought harmoniously into the school curriculum. This is not an easy task, but there is now strong evidence that it can be done. The claims that it shouldn't be done are neither trivial nor frivolous; but they are answerable. Aesthetics isn't just for adults; history shows that it is rooted in the acquaintance we think young people must make with art to become adults. Aesthetics isn't extraneous to the art curriculum; it feeds and strengthens its companion disciplines by showing them their conceptual sources, problems, and interconnections. And aesthetics isn't too hard for children; the salient issues in the field can be liberated from their theoretic matrices to capture the interest and imagination of schoolchildren of all ages, giving them new ways of thinking about art and new ways of cultivating their own aesthetic experiences.

NOTES

1. Howard Gardner, "Toward More Effective Arts Education," in *Aesthetics and Arts Education*, ed. Ralph A. Smith and Alan Simpson (Urbana: University of Illinois Press, 1991), p. 274.
2. The definition of aesthetics and its implications are presented in Marcia Eaton's essay, below, and developed for different contexts in several of the other essays.
3. See especially *Republic* II 376-79; III 392C-403; VII 530C-531.
4. Rousseau remarks: "The world is full of artisans, and especially of artists, who do not possess natural talent for the art they practice but were pushed into it by others from an early age, whether prompted by other considerations or deceived by an apparent zeal which would have similarly led them to any other art if they had seen it practiced as soon. One hears a drum and believes he is a general. Another sees a building and wants to be an architect. Each is tempted by the trade he sees performed when he believes it is esteemed." Jean-Jacques Rousseau, *Emile, or On Education*, trans. Allan Bloom (New York: Basic Books, 1979), p. 198.
5. The notion that there might be a scholarly discipline called "aesthetics" originated with Alexander Baumgarten in 1744; but Immanuel Kant's *Critique of Judgment* (1790) is clearly the first major work that provides a comprehensive

theory of art and aesthetic judgment within the framework of a clearly philo-sophic system.

6. The traditional story is that he was so absorbed by the work that he missed his rigidly maintained constitutional walk for several days, to the consternation of his fellow Koenigsbergers, who set their watches by his passage.

7. John Dewey, *Democracy and Education: An Introduction to the Philosophy of Edu-cation* (New York: Macmillan, 1916), pp. 205-6.

8. Dewey contrasts the social, instrumental, participatory learning of baseball and marbles with the detached and comparatively lifeless regimen of standard art instruction in "Individuality and Experience," in *Art and Education*, ed. Albert Barnes, 3d ed. (Merion, Pa.: Barnes Foundation Press, 1954), p. 34.

9. In an early work, members of the Institute set out their overall objectives: "[E]ven though there is a vast body of learning which goes by the name of 'phi-losophy,' the point of philosophy for children is not to drum that body of knowledge into children's heads, but to keep them from abandoning their natu-ral bent in the direction of thoughtfulness and speculation. The aim is not to get children to learn philosophy, but to encourage them to think philosophically." Matthew Lipman, Ann Sharp, and Frederick Oscanyan, *Philosophy in the Class-room* (West Caldwell, N.J.: Universal Diversified Services, 1977), p. 30. Addi-tional information on philosophy for children can be obtained from the American Philosophical Association's Committee on Pre-College Instruction in Philosophy (Newark, Del.: APA, University of Delaware, 1976).

10. It should not be thought that the Institute for the Advancement of Philosophy for Children has ignored aesthetics altogether. Some results of their research in this area are presented in William Hamrick, "Philosophy for Children and Aesthetic Education," *Journal of Aesthetic Education*, 23, no. 2 (1989), pp. 55-67.

11. The objectives and results of this project have been well chronicled in Getty publications and amply reviewed in the pages of *JAE*. Useful overviews are pro-vided in Stephen Mark Dobbs, *The DBAE Handbook* (Santa Monica, Calif.: The J. Paul Getty Trust, 1992); *Education in Art: Future Building (Proceedings of a Na-tional Invitational Conference)* (Santa Monica, Calif.: The J. Paul Getty Trust, 1992). Also see the special number of *Journal of Aesthetic Education* devoted to DBAE, vol. 21, no. 2 (Summer, 1987), and, more recently, Ronald Moore, "A Suc-cessful Model of Teaching Aesthetics in the K-12 Art Curriculum: The DBAE Program," *Journal of Aesthetic Education* 27, no. 3 (Fall 1993): 51-62.

12. Arthur Danto has been the foremost advocate of the view that art and the phi-losophy of art collapse into each other in the present art world. See Danto's *The Transfiguration of the Commonplace* (Cambridge, Mass.: Harvard University Press, 1981).

13. See Nelson Goodman, "Notes from the Underground," *Art Education* 36, no. 2 (1983). His position is developed at greater length in *Languages of Art* (Indianapolis: Hackett, 1976).

14. See Marcia Eaton, *Aesthetics and the Good Life* (Toronto: Associated University Presses, 1989). See also Edmund Burke Feldman, *Becoming Human through Art: Aesthetic Experience in the School* (Englewood Cliffs, N.J.: Prentice-Hall, 1970), pp. 100-136.

15. Kay Alexander and Michael Day, eds. *Discipline-Based Art Education: A Curricu-lum Sampler* (Los Angeles: Getty Center for Education in the Arts, 1991).

16. John Goodlad, *A Place Called School* (New York: McGraw-Hill, 1984), pp. 219-20.

17. Michael J. Parsons, *How We Understand Art: A Cognitive Developmental Account of Aesthetic Experience* (Cambridge: Cambridge University Press, 1987). See also Parsons's essay "Stages of Aesthetic Development," in *Aesthetics and Art Educa-tion*, ed. Smith and Simpson, pp. 367-72.

18. Parsons's essay in the present volume provides refinements of his earlier ac-count, and the essays by Ellen Handler Spitz and Marilyn Stewart introduce new dimensions to the analysis of stages of aesthetic development.

19. See Albert William Levi and Ralph A. Smith, *Art Education: A Critical Necessity* (Urbana: University of Illinois Press, 1991), pp. 180-207. It should be pointed out that Smith's prescription for art education is not wedded to Parsons's analysis, although it seems to be consistent with it.
20. Donald Crawford presents a very useful analysis of the role aesthetics might play in public schools in "Aesthetics in Discipline-Based Art Education," *Journal of Aesthetic Education* 21, no. 2 (Summer 1987): 227-39. Crawford stresses the importance of dialogue and hypothesis in aesthetic instruction.
21. Further details of the method and numerous sample "cases" are presented in Margaret Battin, John Fisher, Ronald Moore, and Anita Silvers, *Puzzles about Art: An Aesthetics Casebook* (New York: St. Martin's Press, 1989). See also Ronald Moore, "The Case Method Approach to the Teaching of Aesthetics," *American Philosophical Association Newsletter on Teaching Philosophy*, November 1987, pp. 11-15; and Marcia Muelder Eaton, "Teaching through Puzzles in the Arts," in *The Arts, Education, and Aesthetic Knowing*, ed. Bennett Reimer and Ralph A. Smith (Chicago: National Society for the Study of Education, 1992), pp. 151-68. Additional aesthetics puzzles and useful exercises are suggested in John Hospers, *Understanding the Arts* (Englewood Cliffs, N.J.: Prentice-Hall, 1982).
22. E. Louis Lankford, *Aesthetics: Issues and Inquiry* (Reston, Va.: National Art Education Association, 1992).
23. The foundation for Lankford's book was laid in a successful Preservice Course for Teaching and Learning Aesthetics presented by him in 1988 at the Ohio State University. This course (whose development was supported by the Getty Center for Education in the Arts) demonstrated (a) that its teaching methods and the materials developed were workable, and (b) that its projected learning outcomes were achievable, thus adding further support to the argument that aesthetics instruction for children is not only theoretically reasonable but practically attainable. (See *From Snowbird I to Snowbird II: Final Report on the Getty Center Preservice Projects* [Los Angeles: The J. Paul Getty Trust, 1990], pp. 14-16.)

Philosophical Aesthetics: A Way of Knowing and Its Limits

MARCIA MUELDER EATON

When art teachers are encouraged to add aesthetics to their classroom in-struction, one of the questions they most commonly ask is, "Just what is aesthetics?" In this essay I shall try to answer this question in a way that can be applied to the work of young people at various stages of development. I shall also indicate some of the limitations that I believe should be straight-forwardly acknowledged. But perhaps the easiest way of answering this question is by reassuring teachers that, when they do aesthetics with stu-dents, they will know it.

Philosophical aesthetics is the study of the nature and components of aesthetic experience. This simple statement is, of course, a not-very-helpful gloss, for it immediately provokes the question, Just which experiences are aesthetic and who has them? And, in particular, Do children have them and, if they do, can they recognize them sufficiently to study them? I think there is ample evidence that children do have aesthetic experiences (though, of course, they may not call them that). A much tougher question is how we decide which experiences are aesthetic, that is, which experiences we want to study.

Perhaps the easiest way to distinguish aesthetic experiences from non-aesthetic ones is by considering the objects of those experiences rather than by trying to discover some commonalities in the experiences per se. Indi-viduals and social groups, after all, respond and behave in very different ways when they have what they identify as aesthetic experiences. Is there some *one* way you always feel and feel only when you have what you identify as an aesthetic experience? Or think about what goes on when people listen to music. Some sit quietly with their eyes closed; others sit erectly on the edges of their seats; still others tap their feet, shake their shoulders, and generally exhibit lots of movement—all in response to the

Marcia Muelder Eaton, a professor in the Philosophy Department of the University of Minnesota, is Vice-President and President Elect of the American Society for Aesthet-ics. She is the author of *Basic Issues in Aesthetics*, *Aesthetics and the Good Life*, and recent articles in *Philosophical Studies*, the *British Journal of Aesthetics*, and the NSSE Yearbook *The Arts, Education, and Aesthetic Knowing*. She is a past contributor to this journal.

very same sounds. Similar behavioral variations are evident in the presence of literature, painting, dance, film, and so on.

But suppose we do give up on a behavioral definition of aesthetic experience and turn instead to the objects of those experiences—to the artifacts and natural objects that we refer to as "aesthetic objects." Again we face a vast array: symphonies, sonnets, sunsets, serigraphs, and so forth. Since anything, it seems, from coffee mugs to urinals, can be objects of aesthetic experience, one finds oneself immediately confronted with a puzzle: if aesthetic experience is to be identified by its objects, not by some inner state or behavioral set, and if anything can be the object of aesthetic experience, then how can one ever distinguish aesthetic from nonaesthetic experiences? And if aesthetics is the study of aesthetic experience, how, then, can one know if one is doing aesthetics or not? This is the point I made in the first paragraph: as soon as one begins to *talk* about aesthetics, one is forced to *do* it!

This realization can make one's head spin. But at least one knows, then, that one's head is *working*, and this is a major goal of philosophical aesthetics. The admonition to include aesthetics in art curricula is a direct result of the belief that one crucial element of artistic activity is thinking about it. Too often art has been taught as if it were exclusively production or expression, as if, to use current pop-psychology lingo, it were exclusively a "right-brain" activity. We have been warned that too much thinking and talking about art stifles creativity. My own view is that this position is dead wrong. Quite the opposite is true: thinking and talking about art stimulate and re-inforce creativity. Introducing aesthetics into art curricula recognizes that as important as manipulation and investigation of media and expression are, the value of art derives at least in part from the fact that it engages the left side of the brain as well. Reflecting upon our aesthetic experiences and their components is an important and rewarding discipline in itself; it can also be instrumental in drawing students into more rewarding productive activity.

But we are back at the problem of identifying aesthetic experiences. Fortunately for the purposes of incorporating aesthetics into art education, the problem of deciding which experiences are of interest to us is a bit easier to get a handle on than one might initially think. For the class of *objects* that are of interest is already bounded to some extent, namely to *art objects*. Thus the study of the nature and components of aesthetic experience is directed at the nature and components of the experiences people have when they pay attention to artworks. (Later I shall indicate ways in which I think we might extend attention beyond artworks.)

One general way of approaching the nature of aesthetic experience is by asking what goes on when people look at paintings or read literature or listen to music or watch dances or films. But these activities are so diverse and

complex that I prefer another approach. Many theorists have agreed that more specific questions can be directed at certain core components of these experiences:

A. the objects that are the focus of attention (artworks)
B. the makers—persons causually responsible for the objects' existence (artists, performers)
C. the attenders (readers, listeners, viewers—in general the audience)
D. the context of the experience (the art world or the society in which it is located)

Questions about each of these components individually and questions about the relations between and among them are at the heart of philosophical aesthetics.

Individual philosophers have emphasized one or more of these components, and for each of them many questions can be and have been raised. And various answers have been suggested. Many of these answers are elegant and exciting and intrinsically worthy of detailed study. But the most important part of philosophy is articulating clear questions and encouraging students to develop their own positions; and this will, of course, involve some study of what people who have addressed them seriously and intelligently have contributed. Young people at different stages of development will formulate questions differently, but as soon as they begin to ask "Why?" (which we all know is *very* young), they are able and willing to engage in philosophy, for the why-question is at the heart of philosophy, and the readiness with which it is asked is the sure sign that all human beings are philosophers by nature. When "Why?" is directed at artworks, students are able and willing to do philosophy of art or philosophical aesthetics. (In addition to "Why?" there are, of course, other questions that both philosophers and nonphilosophers ask: "What?", "When?", "Who?", and even "Who cares?"—a question that often takes the place of "Why?" when the natural curiosity of people is stifled too long.)

Students at different levels will also, of course, find the contributions of philosophers more or less helpful. Five-year-olds will not read Plato, but some fifteen-year-olds will find some of his writings exciting, if challenging. The latter group love to debate the issue of whether art is "real," and even some five-year-olds are able to think about whether pictures of beds are "as real" as the bed they sleep in. Teachers will discover for themselves which questions work and which philosophers' answers are accessible.

Each of the components A to D above has particular questions traditionally associated with it. (Students may come up with their own and should certainly be encouraged to do so.) These perennial questions are a good starting point. I cannot provide anything like a comprehensive list here, but I hope the following will be suggestive.[1]

A. *Objects*: What is art? What is beauty (or aesthetic properties such as gracefulness, harmony, unity)? Which properties of objects serve to represent, express, convey ideas, act as symbols? What is the metaphysical status of the work: is there only one of its kind (as the *Mona Lisa*) or several (as *Hamlet*)? Is there a difference between form and content? What role does each play? Is there a difference between art and craft?
B. *Makers*: What is creation? What is creativity? What role do artists' intentions play in descriptions and evaluations of their work? How is what a work expresses related to the artist—if a painting is sad, must the artist have been sad when he or she produced it? Is artistic activity primarily intellectual or emotional?
C. *Attenders*: What is an aesthetic experience? What is the role of aesthetic scanning? Why is it important?[2] What is the role of emotion? What is the role of intellect? What is the role of taste? To what extent is aesthetic experience removed from or connected to everyday life? What is the nature of criticism? Are some interpretations of works better than others? Why are aesthetic experiences valuable? If one thinks a work is beautiful, must one also enjoy it? Does criticism affect aesthetic response?
D. *Context*: How is aesthetic value related to other values, for instance, economic, religious, ethical, political, ecological? How does culture determine which objects are art or which objects have aesthetic value? Is censorship ever justified? What role do traditions and history play in creation, interpretation, evaluation? What should public policies be with respect to art? What institutions play primary roles in shaping aesthetic experiences?

Again, teachers can "translate" such questions to accommodate different levels of student development.[3] For example, the question Which properties of objects serve to represent ideas? may for beginners (and there are beginners of all ages—some fifty-year-olds have had very little experiences with sustained questioning about art) take the form of asking what colors can be seen, or whether the music is fast or slow, or whether one can hear rhyming words. One can go on to ask what the colors or speed or rhymes have to do with specific objects or ideas that are represented. Much later, as students become more adept at description and interpretation, more general philosophical issues can be raised: what does color (or tempo or rhythm) have to do with representation in general?

Another way to understand what aesthetics is, is by comparing and contrasting it with art production, art history, and art criticism. Although I believe one cannot separate these activities precisely from one another, one can see differences in emphases. Consider, for example, representation and expression. (Although these examples come from the visual arts, they can be "translated" into other art forms.)

Representation:
1. Production: Make a pencil drawing of a horse.
2. History: Study the ways horses have been represented in different periods.

3. Criticism: Decide whether this is a good drawing of a horse and give your reasons.
4. Aesthetics: What does Plato say about the role of representation in art? Furthermore, since 1, 2, and 3 all play an important role in aesthetic experience, and since aesthetics raises general questions about this experience, there are philosophical questions that can be raised about each. For example:
 4.1 What makes x a representation of a horse? Fill in the blank "X is a representation of a horse if and only if _____."
 4.2 How is historical context relevant to determining whether a particular representation of a horse comes from one century rather than another, from one country rather than another? Does an artist's intention make something a representation of one thing rather than another?
 4.3 What makes something a good reason in support of an interpretation or evaluation? Do facts settle questions about whether works are good or bad representations? Is the fact that a given work is a representation of a horse rather than a pig relevant to its evaluation?

Expression:
1. Production: Make a sad papier mâché mask.
2. History: How has sadness been expressed in different periods and cultures?
3. Criticism: Is this a successful expression of sadness?
4. What is Tolstoy's expression theory of art?
 And again, play-offs from 1, 2, and 3:
 4.1 What makes this sad rather than happy? Fill in the blank "X expresses y if and only if _____."
 4.2 Does one have to know something about the artist's life or culture in order to know that a mask is sad?
 4.3 Is sadness relevant to evaluation? Could a mask that the artist intends to be sad but that makes us happy be a good mask?

There will always be overlap when art educators think of what they are doing as "whole-brain" activity. Evaluation—asking, "What makes a good x?"—will not only require studying how individual philosophers have answered this question, but will also require thinking about how x's are made, whether people in other cultures and times have also made x's, why members of a culture do or do not bother to make x's, and so on.

Including aesthetics in art education can have two different thrusts: asking philosophical questions in the context of artworks for the sake of asking itself and asking philosophical questions as a way of directing attention to specific artworks. Both are valuable, though of course as a philosopher, I will be more apt to find the former satisfying. One may ask, "What is art?" because the question is interesting in itself or because dealing with it sheds light on important developments in twentieth-century Western art.[4] I favor an *aesthetic education* that includes art education rather than vice versa. For one thing, I think there are important aesthetic issues—aesthetic problems

having to do with the environment, for example—that students should be made aware of. How do people's landscape preferences differ from culture to culture, region to region? How can different preferences be handled by public policies? Are ecologically sound environments more beautiful than those which are unhealthy? I believe aesthetic education could meaningfully be extended to cover such issues. But, again, different teachers will differ with respect to the direction and objects of aesthetic discussion.

Some readers may be asking, "Look, we're already being asked to do so much—history, criticism, aesthetics, as well as production. Now do I have to cover the environment as well?" This question arises from the worry that one is already trying to do more than one can do well, and this leads me to the second general topic of this essay: the limits of aesthetics as a way of learning and knowing. Legitimate educational demands spring from the fact that ours is an increasingly diverse society. How does philosophical aesthetics respond to these demands?

I want to suggest three ways in which cultural diversity has affected philosophical aesthetics.[5] The first is positive and significant, but has left the field relatively unchanged. To the extent that aesthetics is the philosophy of *art*, as the concept of art changes and widens, so must aesthetics. For example, when, in the twentieth century, jazz was finally accepted as "real music," philosophers began to worry about problems that it raised—the necessity of a score for determining the identity of a musical work of art, for instance. As photography gradually came to be accepted as genuine artistic activity and not just mechanical recording, art theorists were forced to include photographs when they debated questions concerning the nature of artists and artistic process.

Thus in the last decade or so we find in aesthetic journals and classrooms references to quilts, rap, Caribbean carnivals, African masks, pornography—things that were not cited in my first aesthetic classes in the early 1960s. However, although the kinds of examples discussed have changed, the questions raised remain the same: What is art, what is aesthetic experience, what is the difference between good and bad art? Are there correct and incorrect interpretations? Must one know the intentions of the artist in order correctly to interpret and evaluate a work of art? And so forth.

I do not want to minimize the importance of discussing West Indian carnival costumes as well as Italian Renaissance sculpture, Amish quilts as well as Dutch landscapes. Craft, function, intention, ontological status—all are discussed more fruitfully when as wide a range of artistic examples as possible is drawn on. And, of course, philosophy becomes more accessible to students when objects and activities from their own cultural experiences are taken seriously. But "new examples, same old questions" is still a fair way of describing the first effect that I have observed cultural diversity to have in aesthetics.

The second influence is rather deeper, for it concerns basic assumptions in the philosophy of art. Again, as the meaning of 'art' changes, so must the philosophy of art. Not only must the set of examples one analyzes grow, one must sometimes question the set itself—ask, for example, what qualifications the members of the set must possess. Philosophers of science once took seriously the concepts, assumptions, and methodology of astrology; they no longer do so. Alchemy may interest historians of science, but philosophers of science do not feel compelled to include alchemical discussions of generation in their attempts to explain scientific method. The philosophy of art is somewhat different. Rarely are objects once considered art rejected; instead, the class grows. But the set of basic assumptions radically changes. Aristotle began his famous *Poetics* with the statement, "All art is imitation"—an assumption that permeated philosophy of art (and art) in the West until very recently, historically speaking. When people no longer believe that all art is imitative or representational, philosophers of art are forced to reject the Greek paradigm and suggest new ones.

Throughout most of this century in Eurocentric aesthetics, it has been assumed by many that what is special about aesthetic experience is that it is disinterested (i.e., nonpractical) attention to the formal qualities of objects and events. When one takes the aesthetic attitude, according to many formalist theorists, one puts aside all ordinary concerns (moral, economic, political, religious, etc.) and just focuses on the object for the sake of its own form alone.

Some theorists, of course, never accepted the view that aesthetic value is wholly determined by shapes, colors, linear relationships, and so forth. Marxist and psychoanalytic writers insisted that the aesthetic is greatly influenced by political or psychological factors. And many analytic philosophers suspected that art's value went beyond satisfaction taken in perceptual qualities presented in isolation from other human experiences.

Attention to culturally diverse voices has accelerated and intensified acceptance of the view that form and content are not separable. A growing number of theorists, myself included, do not believe that aesthetic experience (and hence aesthetic value) can be neatly packaged and distinguished from other areas of human concern—politics, religion, morality, economics, family, and so on. Art objects do not always, nor even typically, stand alone. Even if some are created to be displayed in museums or concert halls—above and beyond the human fray—many are intended to fill political or religious or moral functions. Their value is diminished, indeed missed, if one ignores this. This is particularly true of the art of cultures other than the one dominant in the West in the first two-thirds of the twentieth century—the art world of wealthy, white, male connoisseurs.

The story of quilts provides an excellent example of ways in which philosophers of art have been stimulated to revise assumptions. At the core of

formalism lies the strong appeal of the "art for art's sake" attitude. Art, according to this view, does not depend for its value on any practical considerations. Artists are not practical people; they inhabit a realm above that of crafts people. If this network of assumptions is accepted, then everyday objects, and contemplation of them that recognizes them as such, are not genuinely aesthetic. Even very pleasing, wonderfully crafted everyday objects cannot be true art. If they find their way into museums, it will be into special chambers—the "decorative art" rooms. And some everyday objects, because they are overtly intended to be useful and are not created by genuine artists (remember—real artists do not inhabit the ordinary, everyday world), do not even merit a place in the decorative art areas. Thus until very recently one might briefly encounter a sterling silver tea set on the way to or from the oil paintings, but one would not have found a quilt. Quilts were "women's work"—useful, even pretty, but made (not "created") by people who inhabited the real, not the artistic world. My mother, I know, did not consider herself an artist. She knew what that word meant in our culture, and though she cared deeply about shapes, lines, colors, and so on, she knew that her products belonged perhaps at a county fair, but never in a museum.

Thanks to the increasing number and volume of "outside" voices, many museums now display quilts. This signals radical changes in the art world. And corresponding changes mark aesthetics. No longer can one blithely assume that art exists for its own sake, or that there is a firm line between art and craft. Nor can one without question *begin* with the view that aesthetic value is independent and isolated from other sources of value. In my own work, for instance, I currently am attempting to show how aesthetic and moral value are integrated—a view rejected soundly by most Eurocentric aestheticians throughout much of the twentieth century.

Assumptions are questioned when theories and practices of one culture come up against the theories and practices of another. Often the meeting is a crash—noisy and painful. This is true not just of art, of course, but of all areas of human endeavor. (Alchemists did not yield easily or quietly.) But fortunately the meeting is not always unpleasant. I wish to share a personal example. In the late 1970s I gave most of my attention to developing a definition of art. I articulated one that I thought correct—I still like it a lot.

> X is a work of art if and only if x is an artifact and x is discussed in ways such that attention is focussed on intrinsic properties of x considered valuable in the aesthetic traditions of a culture.

One summer in the early 1980s I had the good fortune to lecture on aesthetics to a workshop attended by art administrators, presenters, and educators, and the group was culturally diverse. After quietly and politely listening to a presentation of my definition, one man, an Ogibwa I had come to have enormous respect for in earlier sessions, pointed out that in his culture

artworks are considered sacred—so sacred that one does not *speak* of them. By assuming that *discussion* is central (as it certainly has been in the dominant, verbose Eurocentric art history and theory), I had in a stroke precluded Ogibwa productions from a place in the art world. To make a long story short, after discussions with him and other members of that group, I was able to revise my definition so that I did not disenfranchise whole peoples. (I substituted 'treated' for 'discussed.') We all benefited enormously from this experience—especially I.

Encounters with cultures other than our own are not always so felicitous. It would be a serious mistake to overlook the fact that cultural diversity and the demands it places have met with some resistance—and this is the third effect of cultural diversity on aesthetics that I want to talk about. The resistance has many sources: fear of the other, fear of losing power, fear of diminishing one's own standards of excellence, and often simply fatigue—tired, overburdened teachers and other public servants ask, "Do I have to do *that*, too?"

But I want to talk about another reason for resistance—one that interaction between cultures even when accompanied by positive awareness, enthusiasm, and sensitivity to difference, itself reinforces. It is an unwillingness to do philosophy in a culture other than one to which one belongs because one believes that doing it is impossible.

Cultural diversity has alerted us to a problem that cannot, without peril, be ignored, namely, the extent to which one carries one's own cultural presuppositions and predispositions wherever one goes. This is not wrong, it is inevitable. Without those presuppositions and predispositions, communication and social action are impossible.

Fluency in its language is a prerequisite of competently communicating and philosophizing in a culture. Understanding in a language other than one's own requires a *translation* of the nonnative into the native language. But problems of translation are enormous. We say, "They have a word for it that takes us a page to describe." Or we shrug and say, "They just don't have a word for it." Or we have the same words, but only familiarity with a subculture enables one to understand the differences the same words signal. ("Pretty good" in Minnesota, but not in California, is a term of high praise.) When differences are radical, one can never be certain that one has gotten a correct translation.

Let me give a nonaesthetic example first. Work done recently by philosophers, psychologists, linguists, anthropologists, sociologists, theologians, and others in what is called the social construction of emotion shows that emotion terms refer not just to inner bodily states, but to social practices, attitudes, beliefs, and moral order. For example, there is a small Malay group living in a remote area of northern Luzon, the Ilongot, who have a word, 'marah,' that seems clearly to refer to an emotion.[6] But it seems to

refer to both envy and anger, emotions that seem quite different to English speakers. There are at least three possibilities here:

1. 'Marah' means two different things—anger sometimes, envy sometimes.
2. 'Marah' means one thing, but the Ilongots have an emotional constitution that differs from that of English speakers.
3. We have completely misunderstood and hence mistranslated 'marah.'

Given these translation problems, consider how difficult it will be adequately to understand Ilongot art. Even assuming that the expression of emotion is important in their art—an assumption that itself will require fluency to verify—how will we be sure that a work expresses marah? Is it marah more like our anger or our envy? Or is it an emotion that translation into "envious anger" or "angry envy" at best only approximates?

One lesson of social constructionist theories applied to aesthetics is that one can learn a lot from art—but only when art is broadly construed, construed, that is, not simply as an individual act, but as a social enterprise with a history, marked by collective discussion and analysis and evaluation. One cannot forget that art and its culture are inseparable. Art provides access to culture—but culture also provides access to art. How much one must know about a culture before one has *any* access to art is problematic. How much can I learn from an Ilongot carving? Not much if all I have are my upper-Midwestern eyes.

The Ilongot case is admittedly an exotic, extreme example of why it is so difficult to do philosophy in a culture other than one in which one is fluent. But it is instructive. One topic broadly discussed and debated in contemporary Anglo-American philosophy of art is the role and nature of emotion in aesthetic experience. One of my own articles is entitled "A Strange Kind of Sadness" and deals with the question of whether sadness, fear, and other "negative" emotions we feel in response to works of art are *real*.[7] If films or songs really made one sad, why would one go to such lengths to see or hear them? Philosophers since Aristotle have tried to give a satisfactory account of this puzzle (and students who enjoy sad and terrifying movies are intrigued by the question of why they enjoy them). Discussing it intelligently not only requires a knowledge of the considerable history of the debate; it demands deep cultural fluency—the sort that enables one to appreciate nuances of usages, the sort of experience and understanding of the concept of 'sadness' or 'fear' that only a native or nearly native speaker possesses. There simply is no way that I could or would responsibly try to deal with an analogous problem in a culture in which I do not have nuanced experience, for example, on the role of 'marah' in Ilongot art.

And it is not just a matter of lacking the wherewithal to answer the sorts of questions that aestheticians in one's own traditions raise. It is also a

matter of not knowing or understanding or appreciating the very questions that philosophically engage people operating within a different culture and hence within a different conceptual scheme. Although I have a hunch that the role of emotion in art is probably of interest cross-culturally, it is only a hunch. If it is imperialistic to tell other cultures what their art means or which of their artifacts have value or what they should be creating, it is also imperialistic to tell them what philosophical questions should be answered. One may ask Eurocentric aesthetic questions about non-Eurocentric cultures; there is no guarantee that people in those non-Eurocentric cultures care about those questions.

The manipulation of a symbol system with which one is familiar lies at art's core. This is equally true of philosophy, so doubly true of the philosophy of art. Whether it is Malays, Alaskans, rural Minnesotans, Amish quilters, Black rappers—what we must do, of course, is find translators, native speakers, informers who act as bridges between cultures. Fortunately there are some. An Alice Walker can help us understand not only more about black culture, but about black aesthetic concerns. Anita Desai, who divides her time between Delhi and Mount Holyoke, has helped me through her novels to see how Indian culture and artistic production differ from and are similar to mine. But these people are bilingual, and only bilinguals can do philosophy of art in more than one culture. Unfortunately very few bilinguals, let alone tri- or quatralinguals, are produced by any culture. Many societies have trouble creating genuinely fluent individuals in one. Becoming deeply fluent in another language, of course, takes a great deal of time, and the time required is directly proportional to the distance between cultures. Only full-fledged fluent members of a culture are able to send us their best and help us to appreciate the art of that culture. And when (and only when) we have developed sufficient fluency ourselves can we begin to understand the philosophic questions others raise about their art (and ours), not just raise our own questions. A standard Eurocentric question in aesthetics deals with whether one must know an artist's intentions in order to understand and evaluate his or her work. But in cultures where the artist is not identified or where the very notion of a single individual responsible for the creation of an object does not make sense, such a question will be absurd.

The quilt example is again helpful. Above I spoke positively about the fact that this product of (usually) women's work has recently been accepted as genuine art. But not everyone thinks it is so wonderful to find quilts hanging in museums. Notice that the very question Does this object deserve to be hung in a museum? carries with it a whole network of presuppositions and predispositions. In dominant wealthy, white, male connoisseur culture in the last century, "being good" meant "being qualified to be displayed in fine art museums." But the more we listen to members of the

quilt-producing culture (i.e., to translators), the more we begin to realize that not everyone agrees that this art form should be put aside in this way. A growing number of feminist critics and aestheticians argue that true aesthetic experience of quilts is felt only in their proper context—on real beds, keeping real bodies warm, particularly when those bodies know that this particular piece of material came from Mary's skirt or Joe's shirt. The fact that it will wear out is not negative, but positive. Who benefits when quilts are hung in museums? This very question, which must be asked, will be asked and understood only when "translators" have informed outsiders and taught them enough to understand the quilter's concerns.

If we want knowledgeable informants who will send us their best and give outsiders access to it by instructing us in ways of dealing with it, so also must we as insiders continue to send our best and do what is necessary to grant access to it. This means that deep fluency must be obtained in one's own culture. Who benefits when Shakespeare is no longer required reading? Of course, we benefit from the recognition that a diet exclusively of Eurocentric artworks is not good. Students have too often been made to feel like my mathematician husband who admitted to me after we had once been travelling in Italy for two months that he was beginning to suffer from Madonna and Child overload. Giving up large concentrations of Shakespeare or Giotto—even giving them up completely—may be good if it symbolizes that "ours" isn't all there is. But we must be careful or we lose the ability to send our best—we become cultural dilettantes who have no real fluency anywhere, and hence are unable to do advanced philosophic work.

Some of the resistance to cultural diversity results, then, from recognition that superficial exposure to a variety of cultures will never produce philosophers. But need a philosopher be paralyzed by this realization? I don't think so, but I also think that one must be open and forthright about the difficulties.[8] One must try to develop ways of training bridges and training people who want to learn from bridges. It has been shown that aesthetics is accessible to children; thus we can be optimistic that other cultures' aesthetic concerns can be made accessible to us. This will require serious and thoughtful people who work to develop the sort of sequential, developmental curricula that will lead willing learners to increasingly sophisticated levels of philosophical skill and insight.

NOTES

1. There are several introductory books. I recommend George Dickie, *Aesthetics: An Introduction* (New York: Pegasus Books, 1971); Anne Shepard, *Aesthetics: An Introduction to the Philosophy of Art* (Oxford: Oxford University Press, 1987); and, of course, Marcia Muelder Eaton, *Basic Issues in Aesthetics* (Belmont, Calif.: Wadsworth Publishing, 1988).

2. Too often, 'aesthetics' has been *defined* as 'aesthetic scanning.' As this essay will show, I think aesthetics involves much more than the description of a work's properties.
3. Other essays in this collection will provide expert advice about specific curricular methods and resources for including aesthetics in art education at different levels.
4. In making this distinction, I am grateful to Brent Wilson for helpful discussions.
5. Much of what follows was presented at a conference on cultural diversity in aesthetics sponsored by The Getty Center for Education in the Arts in Austin, Texas, August 1992. I am indebted to them for their support and for the opportunity to share and discuss my ideas with conference participants.
6. Paul Heelas, "Emotion Talk across Cultures," in *The Social Construction of Emotion*, ed. Rom Harre (Oxford: Basil Blackwell, 1986), p. 240 ff.
7. Marcia Muelder Eaton, "Strange Kind of Sadness," *Journal of Aesthetics and Art Criticism* 41 (Fall 1982): 51-63.
8. An admirably modest attempt to introduce non-European aesthetics is Richard Anderson's *Calliope's Sisters* (Englewood Cliffs, N.J.: Prentice-Hall, 1990).

I am grateful to Virginia Fitzpatrick, Douglas Lewis, and several of my students for helpful comments on an earlier draft of this essay.

Can Children Do Aesthetics? A Developmental Account

MICHAEL J. PARSONS

This essay will address the question whether there are developmental aspects to learning aesthetics. Do children typically think in ways that are different from those of adults and that affect their abilities to learn aesthetics? Do children hold typical early forms of aesthetic theories? What can we say in general about cognitive development and aesthetics?

In what follows I will argue, mostly by means of brief examples, that children do in fact think in characteristic ways about the arts and have, at least implicitly, philosophies of art. Moreover, these implicit philosophies of art are shaped by the development of important underlying cognitive abilities. In turn, they determine to a large extent the kind and range of aesthetic response that children are capable of. This latter point amounts to the claim that the development of abilities with respect to aesthetics is closely related to the development of the more general abilities required for mature aesthetic response.

Ronald Moore, editor of this collection, framed the question in the following way. Kant's ethics, he suggested, can be read as an attempt to show what are the key abilities required for someone to be a moral adult; for example, autonomous thinking. Kant saw that there are earlier stages of human development in which these key abilities are not yet present but are in preparation, in which one can trace the developmental precursors of those abilities. In the same way, Moore suggested, one might ask parallel questions about aesthetic adulthood. What are the key abilities required for a mature aesthetic response, and what are the steps by which one acquires those abilities? This question comprehends more than just the abilities required to understand aesthetics, though it is important to see that the two are related.

Michael J. Parsons, Professor and Chairperson of the Department of Art Education, Ohio State University, is the author of *How We Understand Art* and coauthor of *Aesthetics and Education*. He is a past contributor to this journal.

I

I will begin with the connection between the two sets of abilities: those required to do aesthetics and those required for mature aesthetic response. My claim is that they *are* closely connected. The connection runs both ways. In one direction, one needs to have a mature response to art in order to understand the philosophy of art well; in the other direction, one needs to be able to think philosophically about art to be an aesthetic adult. This means that aesthetic development in general includes the development of abilities with respect to aesthetics (for clarity I will henceforth often say the "philosophy of art" in place of "aesthetics").

The first of these claims seems noncontroversial: that one needs to have a sophisticated response to the arts if one is to do philosophy of art well. The reason lies in the content. Philosophers of art discuss, for example, the nature of aesthetic qualities, the criteria for judgments, the relevance of context. It follows that they need themselves to have experienced aesthetic qualities, have made judgments, have encountered artworks in and out of context.

The second claim is less obviously true and is in fact controversial in art education circles. Does one really need philosophy of art to deal well with art? It seems that there are plenty of counterexamples. In the past, many people have seemed to pick up, in the normal course of socialization, what they needed to understand art without the need for explicit philosophy. And while there is a growing sympathy in art education for teaching art in context—for including art criticism, art history, anthropology of art in art classes—there is less sympathy for teaching aesthetics. For many, it is less intuitively obvious that one needs aesthetics to understand art. But that belief—that the philosophy of art is implicated in an understanding of art—is the primary reason for teaching it in schools. Perhaps this point extends even to undergraduate education.

One way to justify the claim is to point to the character of our contemporary art world and the society it reflects. In a society that is relatively homogenous and changes slowly, people may come to understand their art without needing philosophy. But our world is a world of great variety and rapid change, wherein it is easy to become confused. It is a world where erasing a drawing may count as making an artwork and wrapping a museum as having an exhibition; where the lines between popular, folk, and fine art have almost disappeared; where there is a multiplicity of styles, media, histories, theories; and where no one stream of thought dominates. Arthur Danto has famously said that artworks exist only in "an atmosphere of theory." The dictum seems true of our age, even if it was not true in earlier times. One cannot understand our art world today without some sense of theory.

The other side of this coin may be a shift in one's sense of what teaching philosophy of art is like. If the purpose is to help students (children or undergraduates) with art, rather than with philosophy, then we should perhaps teach it in the context of also teaching art. The "aesthetic adult" is not a professional philosopher of art any more than she is an artist, art critic, art historian or anthropologist of art.

This means that the abilities we are interested in will have less to do with abstract logical reasoning and more to do with the substance of aesthetics than some may suppose. I am not clear whether this marks a difference with the Philosophy for Children movement, in which a major goal seems to be the development of logical reasoning.[1]

II

What do we mean by an "aesthetic adult"? She is a familiar if shadowy figure, for she is the one to whose judgment philosophers of art typically appeal when they argue a point: That *this* is the way experience unfolds, criticism proceeds, concepts are used, or criteria employed. The appeal is usually implicit, of course, but sometimes it is explicit. For example, R. G. Collingwood argues thus:

> Since the artist proper has something to do with emotion. . . . what is it that he does? . . . Nothing could be more entirely commonplace than to say he expresses them. . . . The idea is familiar to every artist and to everyone else who has any acquaintance with the arts. To state it is . . . to state a fact, or supposed fact, about which . . . we shall have later to theorize philosophically.[2]

I have space only to make some preliminary distinctions about aesthetic adulthood. It is clear, however, that, following Moore's suggestion, we should look for a full description to philosophers of art. We can read much of what they say as an attempt to spell out a description or something closely related to it. Obvious examples are Monroe C. Beardsley's discussion of the nature of aesthetic experience and Danto's arguments that responses to artworks are always interpretive.

Aesthetic adulthood, we can say, means being able to respond appropriately to the art of one's society. This includes being able to interpret artworks meaningfully and to respond to them relevantly, to place them in context, to understand their kinds, to value some for relevant reasons, to discuss them in a critical way. This list sounds quite cognitive in character, but it does not exclude strong emotional response. "Responding relevantly" might well include responding with marked emotion. The list reflects the current general consensus in philosophy that aesthetic response, and emotion in general, is cognitively structured and interpretive in character.

One can distinguish this general sense of aesthetic adulthood from the end point of several schemes of development in the arts. Many of these are really about artistic rather than aesthetic development; that is, about the development of abilities required to make art. The best known is the account of the development of children's drawings that stems from Viktor Lowenfeld and has been amplified by many others.[3] According to this account, children begin to draw by making marks whose character is determined mostly by the physiology of arm, hand, and fingers. Then, in a typical developmental sequence, they associate their marks with representational meanings; they produce tadpole figures and other schema that they understand as representations; they gradually elaborate their figures; they begin to master a number of the devices of visual realism. Many children stop drawing at this point, before they attain significant skills of visual realism. If they persist, they may go on to develop various ways of expressing emotions and to experiment with formal arrangements.

There are other similar schemes of artistic development one could mention. Claire Golomb has investigated children's abilities to make small sculpture figures.[4] David Feldman has looked at making maps and painting with watercolors.[5] These schemes are interesting, but they are not well connected with aesthetic adulthood. They are about the development of particular skills in particular artistic domains and not about aesthetic development in general. These skills will at best overlap partially with the development that leads to aesthetic maturity. The overlap occurs because presumably when people make art they attempt to produce the sorts of things that they understand artworks to be. Also, in the process of making, they respond as best they can to the work they are making. In this way, artistic development will reflect aesthetic development. On the other hand, making things as specific as ceramic figures, maps, or watercolors requires particular skills that may not be related to general aesthetic maturity at all.

Howard Gardner and others at Project Zero have looked at the development of abilities to recognize artistic styles, expressive devices, and other specific items of perception.[6] However, in general their investigations have been oriented toward behaviors and not toward the abilities required to understand these things as parts of aesthetic objects, or artworks.

III

A question immediately arises about the culturally specific character of aesthetic adulthood. Collingwood appears to have had in mind well-educated English people of his time, and it is not clear what he would have said about a well-educated person from, say, an Asian or African tradition. Can we talk only about a mature adult in a particular aesthetic traditon, which

means within a particular culture, or are there universals that stretch across different traditions and cultures?

The Kohlbergian stream of moral developmental psychology has often been accused of cultural imperialism, that is, of assuming that the rest of the world can be assessed on a developmental scheme that actually maps only the development of twentieth-century Western moral understanding. I suppose a parallel claim might be levelled against Kant. At this point, I want only to acknowledge the importance and the complexity of this issue. I am much less sure about it than I used to be. For example, I find the question of just what "universal" means, and just what is asserted by Kohlbergian schemes to be universal in character, not an easy one. I am content to acknowledge that what is said here may be relevant only to the understanding of Western art and, correspondingly, of contemporary Anglo-American or Western philosophy of art.

No one doubts that the content of our understanding of art as we grow up is dependent on the art that we encounter and the cultural context in which we encounter it. The quotations that follow make it clear that much of what children say about art is culture bound. What is not obvious is whether underneath the particular content there are some universal achievements or developments, such as the recognition of the subjective character of individual experience.

IV

What is the basic motive behind cognitive development? It is a principle of the pragmatist tradition that lies behind cognitive developmental theory that children are actively engaged in making sense of the society they are born into. They are born into the art world of their society, and they try to make sense of it. In our society, I have claimed, this means that they will encounter conceptual difficulties. They will have to develop theories of art to deal with the difficulties. They may not become self-reflective, systematic, and argumentative philosophers and may not have explicitly formulated general views about art, but they will struggle to make sense of the art they encounter. They will have at least *implicit theories* about art.[7] And they will probably change their theories as they encounter new types of art or as they develop significant new abilities.

Developmentally, we should be able to identify some typical early implicit theories of art. We might also be able to arrange them in some developmental order in light of their adequacy as theories of art. We might also identify some underlying psychological developments presupposed by the theories. I will give some brief and, I hope, suggestive accounts in what follows.

V

I will identify two typical implicit theories of art that might serve as milestones on the road that leads to a mature philosophy of art. The examples come from actual responses of children to paintings. They are drawn from my research interviews with children of several years ago, and I believe they are representative of typical developmental moments.[8] In the discussion I will attempt to identify the implicit theory behind the response.

The first case is a response to a painting by Ivan Albright, *Into the World Came a Soul Called Ida*, which is in the Art Institute of Chicago (fig. 1). It represents, in an exaggerated and dramatic way, an older woman in her dressing room who has been ravaged by ill health or drugs and is looking despondently into a mirror. I have asked many children to talk about reproductions of this work. Many elementary-school-age children reject it quite decidedly as being ugly and unpleasant. Such children attend almost wholly to the appearance of Ida the person and are repelled by it.

Asked what might improve the painting, they often suggest using more cheerful colors, deemphasizing Ida the person, painting over some of her imperfections, and even choosing another subject altogether. For example, Blair, twelve years old, wanted a more conventional subject. He said:

> (How could you improve this painting?)
> Well, if you showed a woman sitting in a boat, and a lake behind her and stuff; or a couple of deer in the mountains . . .

Children who reject the painting in this way usually assume that other viewers will share their reaction. They take Ida's ugliness as a plain and public fact and make no empathetic reading of her state of mind. They cannot imagine that the artist had any different view of it or understand why he chose this subject. An emphatic example comes from Geoffrey, who was fourteen years old:

> (Why did the artist paint this?)
> To show what people are like, people do this all the time. And they just sit around and vegetate and dwindle away. And they look in the mirror and wonder why. "Oh, I'm so depressed! Look at me now!" You know. She should fight it. It wouldn't be a bad time to start, she's not dead yet. Let me tell you, my mom goes to a health spa. So when I see a fat person like this, it really makes me squirm . . .

Another example comes from Debbie, who was age thirteen:

> (What do you see in this painting?)
> There's a lady sitting in a chair with her legs exposed. They're bare and they're really ugly. They've got bumps all over them, and she's sitting there with a powder-puff in one hand and a mirror in the other. . . . She sort of looks like a witch.
> (What's the feeling in this painting?)

Fig. 1. *Into the World There Came a Soul Called Ida* (1929-30), by Ivan Le Lorraine Albright (American, 1897-1983). Oil on canvas, 142.9 x 119.2 cm. Gift of Ivan Albright. The Art Institute of Chicago.

I don't like it.
(Why not?)
I don't know. It's just that the legs are getting on my nerves.
(Why do you suppose the painter painted it?)
He was angry with his mother-in-law (laughs). I don't know. He just felt like it. He saw some lady going down the street and he said "That looks sickening," and so he decided to paint her. He was angry at her for some reason.

These responses have a holistic character. They seem all of one piece;

they have a structure. This is because they are founded on some assumptions about art that I am calling implicit theories. These implicit theories can be seen as developmental precursors of a philosophy of art. The children hold them as a set of unarticulated expectations rather than as explicated theories, it is true. But they can be formulated to reveal their similarity with philosophical views.

For example, one assumption that seems to underlie the opinions quoted above has to do with art as representation. The children seem to believe that there is little important difference between the qualities of the painting and the qualities of what is represented in the painting, between Ida the painting and Ida the person. They respond to the first in much the same way they would respond to the sight of the second. It is as if they hardly attend to the painting itself but only to Ida the person. They talk about Ida as if she were an actual person, they attribute Ida the person's qualities to the painting. The assumption is that as Ida the person is ugly and unpleasant, so is Ida the painting. This pattern is well known in the literature and is sometimes called the "transparency" view. Children tend to look through the painting as if it were transparent and at the objects represented as if they were actual. This comes through in the moralistic overtones of Blair's remarks quoted above: "She should fight it. It wouldn't be a bad time to start, she's not dead yet . . ." The tone suggests a sense of almost moral outrage, clearly directed at the qualities of what is represented rather than at the painting. Incidentally, I think something like this mixture of moral feeling with aesthetic response comes through sometimes in the responses of some adults in our society who object to paintings with religious or sexual subject-matter, archetypally to the portrayal of nudity.

Philosophically, one might say that these children assume a simple form of a representational theory. They seem to believe that painting is documentation, that we look at it as a substitute for the real thing, and that the things represented should be interesting in their own right.

Another assumption has to do with beauty and ugliness. The children seem to believe that beauty and ugliness are objectively identified and that the ugliness of a painting is identical with the ugliness of its subject. Philosophically, this looks like a version of the view that beauty is an objective value, capable of existing independently of people.

I believe these assumptions depend on a typical developmental-psychological situation. Blair, Debbie, and Geoffrey have not yet become aware of their own interpretive activity and how it influences the character of their responses. They assume that they see directly what in fact they interpret. They see Ida's ugliness as fact and not as value judgment, as if they themselves make no contribution to it, as if it lay on the surface of the work to be identified as simply as her hands and legs are identified. They have no reflective sense of their own values and of how those values reflect their socialization. One could say that they are unaware of the subjective character

of their experience and of the extent to which it might differ from that of others.

VI

My second example concerns older students. During adolescence, most people take a marked subjective turn: they become very aware of the character of their own emotions. They also realize that their experience owes much of its qualities to personal factors. They realize that it is determined in part by their history and may differ from that of others. They are also conscious of the difference between how one is supposed to feel in certain situations (such as when looking at a famous painting) and how they actually feel. Their theories of art are much affected by these developments.

This is from a discussion of a reproduction of a Picasso with a student I will call Harriet:

> (Do you think you can give reasons for judgments about art?)
> No, I think it's so—it's your human feelings. I think you can *say*: "This one has great brushstrokes." You can say these things, but when it comes right down to it, I think, from my point of view—I don't know critics that well—I think it finally boils down to just your gut reaction to the painting.
> (Is that more an emotional than a cognitive thing?)
> For me it is. I don't know, I'm not exposed to a great deal of art. So for me it is a total emotional reaction, which is my reaction to stories, or plays, or anything. If I can connect with it somehow emotionally, then I can go with it, and become one with it. But if there's no connection emotionally, I would—you know, it can be the greatest Picasso, and I, generally with his abstract ones, I don't connect at all. And yet he is considered one of the greats. He is all this but I don't connect with it emotionally.

Harriet's theories of art lie close to the surface here. The purpose of art, she suggests, is to provoke emotion in the viewer. Emotion in the viewer is an all-or-nothing affair, not something about which one could easily be mistaken, because it is a matter of immediate experience, a "gut reaction" directly felt. And one's gut reaction may have little to do with what others say we should feel. Often, this insistence on the felt emotion of the viewer is accompanied by a parallel insistence on the emotion of the artist. These too must be actually felt. For example, this is from a conversation with Kathy, an undergraduate student:

> (Is it possible to paint a painting that is expressive without having a deep need to do that?)
> I would think it wouldn't be real, genuine.
> (Can you tell that from the painting?)
> I don't think, I don't think it would be [genuine], if the artist was just painting to put something on the canvas. I tend to see through things

like that. I don't have a trained eye and I wouldn't know for sure whether it was intentional [i.e., genuine] on a how-it-was-done point of view. [But] from an inner sense of myself I would know the artist wasn't trying to express. I couldn't relate to it anyway.
(You are saying you can tell by looking at the painting whether it's honest?)
Kind of an inner feeling about it.

The structure of Kathy's theory of art seems not unlike Harriet's. The artist must have some genuine (i.e., actually experienced) emotion. The work is good only if this emotion is expressed in the work. The viewer can tell in a direct way whether the emotion of the artist is expressed in the work, through an "inner feeling." This structure has strong Tolstoyan overtones, especially if we assume that the viewer's inner feeling is the experience of the same emotion that the artist had.

Finally, such a theory leads easily to skepticism about the value of critical talk or contextual information about artworks, something familiar to all teachers of aesthetics. Ingrid, another undergraduate, said:

(Do you think someone who has studied Picasso could take you through his works and talk about them and change your view?)
I don't know that it would change. I think that my bias might be deeply enough embedded that I would probably say: "Oh, I'm sure he's a very good painter but I still don't like his work . . ."
(Do you think you could be brought to say: "Yes, that is a significant work of art, even though it doesn't connect with me?")
I think a lot of that would be just kind of going along with the flock. If everyone says it's great, then you kind of join in. I guess you could look at something on a technical level and say: "Yes, technically it's a wonderful work of art."
(And what about expression?)
If you don't see it, I don't think you see it . . . For your personal feelings, I don't see how you could say: "I don't really like this, but I'll keep it around anyway to look at because it's technically perfect."

Here Ingrid suggests a theoretical opposition between experienced feeling and what she calls "technique." Technique is something that can be seen, analyzed, discussed, and judged interpersonally. This is the domain of criticism. Its opposite is emotion, which is intuitive, unanalyzable, and individually experienced. These differences are such that the former cannot influence the latter, and consequently criticism has no important effect on experience. And in any conflict of criteria, emotion must win out over the technical. It is no wonder that our three students see little point in art criticism or history.

Behind these theories of art there are probably further theories of the nature of emotions. Harriet, Kathy, and Ingrid all seem to assume that emotion is individually felt, qualitatively distinctive, not easily communicated, and not much affected by other people. They tend to see experience as

noncognitive and are tempted toward solipsism. One could expect them to have difficulty understanding how experience can be shared, how it responds to objective features of a work, and how common standards of relevance can emerge.

VII

There is more to be said about these examples, no doubt. But I hope I have said enough to make the following points plausible:

a. Students make assumptions of a general kind about the nature of art. They hold these assumptions at varying levels of explicitness and rarely examine them critically. But if the assumptions are spelled out, they look in many ways like theories of art. In terms of content, they can be linked developmentally with the philosophy of art, that is, understood as typical early versions of a mature philosophy of art.

b. To call these assumptions philosophical is to say that they have a cognitive structure that has some degree of internal consistency and stability to it. It is also to say that philosophers can recognize in them certain characteristic concepts, moves, and positions familiar from academic philosophy. They can also identify characteristic difficulties and problems to which they are vulnerable.

c. We may be able to relate these cognitive structures to underlying psychological developments, such as a reflective awareness of the subjective character of experience. This is a further reason for describing these assumptions as developmental.

d. Students' assumptions about art are importantly related to their actual aesthetic experience. On the one hand, they are a product of the students' struggles to make sense of the artworks they encounter. On the other hand, they affect students' responses to artworks. They influence what students count as art, what kind of interpretations they make, even their motivation to think about art. This dependence of experience on assumptions allows one to say that one's theory of art is important to one's experience of it.

VIII

I will close by considering briefly the educational consequences of this kind of account of the development of the philosophy of art.

I have already mentioned one consequence. It offers a rationale for giving the philosophy of art an important place in art classes. We should help students develop better theories of art so that they can make better sense of their experience of art and can experience art differently. One might ask whether this rationale also applies to the teaching of aesthetics at the college level, if we think the purpose of that teaching is to help improve undergraduates' theories of art.

There are perhaps two general ways we can help students improve their implicit theories. One is to get them to articulate and clarify their present theories. This is not easy, but it can be a powerful impetus for change. Few students have the stimulus and the opportunity to state and restate their fundamental views about art and to consider their consequences. Pedagogically, it requires careful support, structure, and considerable time. Currently it happens, if at all, during class discussions and when students write papers on art-related topics. A second general method is to choose class materials in light of the students' assumptions and understandings. Their implicit theories will determine what they will understand and which kind of problem they will find provocative. The idea is to present students with materials that challenge or stretch their implicit theories, that cause them problems but that are not out of reach. For example, the students quoted above in section 5 would probably not understand the students quoted in section 6, because they have not yet constructed the possibility of radical subjectivism. The students quoted in 6 would not easily understand the view that emotions are cognitively structured and socially constructed. They would more likely understand Tolstoy than Danto. And they might be provoked by questions about the possibility of cross-cultural understanding, which for the younger children would not be puzzling at all.

A developmental approach is sympathetic with the puzzles of the sort that Battin discusses elsewhere in this collection, though she does not stress their developmental aptness. Another useful kind of material is the writings or talk of the students themselves, such as the quotations in sections 5 and 6. Students are likely to be able to follow and be provoked by each other's interpretations and theories.

Most of all, this approach would tie the teaching of aesthetics closely with the teaching of art. Artworks would be the perpetual point of departure and return for the discussion of philosophical problems. The most motivating problems students have are probably those presented by difficult works of art. For example, the Albright painting referred to in section 5 would be useful for stimulating discussions with those children about beauty, the purposes of art, and the attraction of ugliness. Moreover, constant reference to particular works keeps discussion meaningful. In the schools, I believe aesthetics should be so integrated into art classes that students are hardly aware of the transition from one to the other.

NOTES

1. See, for example, Matthew Lipman, *Philosophy Goes to School* (Philadelphia: Temple University Press, 1988); Matthew Lipman and Ann Sharp, eds., *Growing up with Philosophy* (Philadelphia: Temple University Press, 1978).
2. R. G. Collingwood, *The Principles of Art* (New York: Oxford University Press, 1958), p. 109.

3. See, for example, J. DiLeo, *Young Children and Their Drawing* (New York: Brunner/Mazel, 1970); R. Kellogg, *Analyzing Children's Art* (Palo Alto, Calif.: Mayfield Publications, 1969); Howard Gardner, *Artful Scribbles* (New York: Basic Books, 1980).

4. Claire Golomb, *Young Children's Sculpture and Drawing: A Study in Representational Development* (Cambridge, Mass.: Harvard University Press, 1974).

5. David Feldman, *Beyond Universals in Cognitive Development* (Norwood, N.J.: Ablex, 1980).

6. See, for example, Howard Gardner, "Style Sensitivity in Children," *Human Development* 15, no. 3 (1972): 325-38; Ellen Winner, *Invented Worlds* (Cambridge, Mass.: Harvard University Press, 1982). For a general review of the work of Project Zero, see the special issue of the *Journal of Aesthetic Education*, vol. 22, no. 1 (Spring, 1988).

7. The notion of "implicit theories" in psychology is usually associated with the work of George Kelly, see George Kelly, *A Theory of Personality* (New York: Norton, 1955).

8. Michael J. Parsons, *How We Understand Art* (New York: Cambridge University Press, 1987)

Vincent's Story: The Importance of Contextualism for Art Education

ANITA SILVERS

Wherein lies the innocence of the innocent eye which, untutored and un-laden with cultural baggage, is supposed to permit all of us, erudite and unlettered alike, to be utterly responsive to art? The presumption now preponderantly operative in teaching youngsters about art is that words about artworks at best are peripheral to, but more usually distract us from, genuine aesthetic responsiveness. Moreover, the attractive egalitarianism attendant on this presumption about unschooled responses to art being most authentic makes us wary of inhibiting students by introducing elitist abstractions and memorials.

Thus, despite decades of well-organized, well-funded, and well-informed efforts, the program to install aesthetics and art history in the schools remains frustrated. It is impeded by the prevailing aversion to these subjects, which, additionally, fall under suspicion as being tools for subordinating self-expression to class or cultural interests. Nevertheless, given our allegiance to—indeed, or ardor for—the innocent eye, we are curiously ineffectual in liberating our perceptions of art from being powerfully influenced by acquired beliefs.

A True Story about a False Story

It was several years ago, while working with a group of elementary and middle school teachers in a program that placed visual artists in their schools, that this puzzling circumstance thrust itself at me as inescapable, but not irresolvable. My assignment was to show both artists and teachers how to integrate an "aesthetics" component into their arts education curricula. Because they were convinced that nothing said, as opposed to shown, to students could critically influence responses to art, they resisted as unnatural the state education department's mandate to teach aesthetics. But

Anita Silvers is a Professor of Philosophy at San Francisco State University. Her most recent articles appear in the *Journal of Aesthetics and Art Criticism*, the *Journal of Philosophy and Medicine*, and the *Journal of Social Philosophy*.

was their reluctance an authentic reflection of their experience of art or just another theoretically induced practice?

To test whether, despite their denials, nurture instead of nature controlled what they saw, I decided to make an intervention so that all of us might observe the outcome of revising their "cultural baggage."[1] I had been reviewing the usual aesthetic theories, illustrating each by applying it to paintings by Vincent Van Gogh. My audience's repudiation of theory softened slightly with the introduction of Tolstoi's proposal that the artist's sincerity is necessary and sufficient to the goodness of the artist's art. Taking this positive reaction as a clue to their tastes, I designed a story to transform my audience's convictions about whether the artist whose works they just had viewed satisfied Tolstoi's aesthetic rule. If changed beliefs about the artist precipitated changed responses to the artist's art, influences beyond the art's directly seen properties would seem to have emerged.

I commenced, during a break, to circulate a story "from the cutting edge of the scholarly community," one which, I disclosed, would be confirmed in a *New York Times* story within the coming week. In a conversational tone, I observed that historians had recently made discoveries that threw into question the dating of the Van Gogh paintings we had been discussing. With the passing of Vincent's nephew's wife, I narrated, scholars had gained access to family papers that showed that the famous incidents of Vincent's life actually were fabricated to increase the value of his art. Far from dying in the depths of madness, Vincent sat down and wrote all the letters to Theo in one month, faked his death, then returned to Holland, changed his name, lived a long and happy bourgeois family life on the proceeds of his growing sales, and, of course, never painted again. News of this discovery had for some time been circulating through the scholarly community.

Then we returned to looking at slides of Vincent's work. Now the participants' comments were quite different: characterizations like "hectic" and "contrived" replaced "exhilarating" and "fresh." Asking my audience to reflect on these revisions, I revealed that my story about Vincent was fiction. But however briefly their beliefs about Vincent had been altered, my audience's aesthetic responses seemed indelibly transformed. Indeed, it seemed so much the worse for how Van Gogh's paintings now looked to them that the beliefs engendered by my fictitious report were false. One person even complained angrily that, although what I had reported "was just a story," his enjoyment of Van Gogh's paintings "would never be the same again."

What had altered so profoundly? Notice that my intervention induced no durable change in anyone's substantive beliefs about the facts of Vincent's life. For presumably any such shift would have been remedied forthwith when I branded my narrative fictitious.

But my admission exacerbated rather than soothed their disturbance, a

circumstance suggesting that it was their recognition of the power of words to modify aesthetic response, rather than the particular modification they experienced, that puzzled or perturbed my adherents of pure aestheticism. Yet my words altered neither the art's description nor any application of theory to the art. In the real puzzling case that developed unexpectedly from my fictional puzzle, words about an artist seemed to be transfigured, whether legitimately or deceptively, into words about the artist's art. This phenomenon is commonplace. But it is rarely explored (except within the narrow constraints of a preoccupation with expression theory) and little understood.

The Elevation of Purely Aesthetic Experience

That words about art can make us find it good or bad, rewarding or disagreeable, is a venerable presumption, for art writing dates from antiquity. But in the philosophical climate toward the end of the eighteenth century, the persuasion that only plainly perceivable properties—ones that do not have to be learned—are pivotal in our reactions to art began to gain ground. Moreover, modern thought differentiates sharply between what is internal to, and what is beyond, experiencing subjects, situating what is common in humans in the former and what is diversifying in the latter location. When value is grounded in the common human condition of experiencing subjects, treating audiences homogeneously becomes a controlling concern. By the mid-twentieth century, the dominant commitment of European art is to a modernism which imagines that the most powerful art is as accessible to children as it is to mature and informed audiences and that it is equally accessible to the peoples of all nations regardless of class or culture.

Hume assigns learning two quite different ways of influencing our enjoyment of art. We are propelled along one route by his realist presumption that, roughly, the greater our experience with artworks, the more skilled we become in perceiving aesthetic properties. The more individuals' experiences with art overlap so as to give them exposure to the same properties, the more reliable the expectation that their tastes will converge. But there is also doctrinal learning, and here Hume holds that diverse moral and religious beliefs intractably polarize tastes. So this latter kind of education is inferior to that devoted to broadening direct perception.

Kant picks up this theme, urging repeatedly that neither taste nor genius can be learned because their operation is antithetical to studious preparation: no prearrangement of rules or concepts can originate the freely attained satisfaction experienced as taste. "(The natural gift for beautiful art) cannot be reduced to a formula and serve as a precept, for then the judgment upon the beautiful would be determinable according to concepts."[2] Genius contributes originality and is disciplined by taste, which "gives

guidance as to where and how far (genius) may extend itself if it is to re-
main purposive."[3] But Kant never totally dismisses the relevance of learning.
He says:

> for beautiful art in its entire completeness much science is requisite,
> e.g. a knowledge of ancient languages, a learned familiarity with
> classical authors, history, a knowledge of antiquities, etc. And hence
> these historical sciences, because they form the necessary preparation
> and basis for beautiful art; and also partly under them is included the
> knowledge of the products of beautiful art . . . have come to be called
> beautiful science.[4]

What role does information contributed by the beautiful sciences play in
our responding to art? Distinct from beauty, but associated with it as genius
is with taste, is what Kant calls spirit. This is the faculty of presenting what
he calls aesthetical ideas, imaginative representations that occasion thought
abundantly without any definite thought, that is, any concept, being ad-
equate to them. Genius shows itself in the enunciation or expression of
aesthetical ideas which contain material felicitous to a design. So genius
seems purposive, but is so abundant as to seem also to be unconstrained by
a predetermined scheme. It takes no genius to reproduce the product of a
genius, but, "(it may) be followed by another genius, whom it awakens to a
feeling of his own originality and whom it stirs so to exercise his art in free-
dom from the constraint of rules, that thereby a new rule is gained for art,
and thus his talent shows itself to be exemplary."[5] For Kant, learning is a
source from which comes an abundance of material for aesthetical ideas
and, as well, of exemplary artistic predecessors. These constitute the context
within which novel works are seen as comprehensible but not conforming.

By the turn of the next century, learned context, banished by Hume and
Kant from foreground to background, is so repudiated as to be thought to
adulterate, rather than enhance, responses to art. Despite his own more
qualified view, Kant's elevation of form ultimately reduces learning about
art to making art. This is because to originate form, and equally to appreci-
ate original forms, is thought of as an inspired process incompatible with
formal education, at least in the sense in which learning rules or acquiring
habits is at the core of formal education. This stance evolves into a convic-
tion that to teach art is foremost to dissolve obstructions to an individual's
creative self-development, rather than to impose constructions derived from
the work of others. Thus, a recent review of contemporary art education
states: "Anyone who has been in art education for any length of time will
recognize the Modernist theme of self expression has been dominant in the
field since the 1930s."[6]

In twentieth-century views about what to teach about art, Clive Bell's
well-known prohibition against permitting thoughts about anything but
form to invade our experience of art has evolved into a dogma. In an

equally famous diatribe against the dreariness of aesthetics, J. A. Passmore sees no need to give reasons for asserting that talk about artists is no remedy for what he considers to be the prevailing dullness of talk about art. "How can it be more interesting? Perhaps by telling stories about artists— 'how one was very poor and kept a little dog and so on.' But this . . . is certainly not aesthetics; it is not even criticism."[7] What is disappointing about Passmore's unequivocal prohibition here is that it violates his own standard of affording ordinary practice precedence over theoretical constraint. He himself observes that while aestheticians are arguing over abstractions, "meanwhile people go ahead with their ordinary aesthetic discussion . . . quite as if they were concerned here . . . with particular matters of fact. And if this were not so, criticism, education, controversy, would be impossible."[8]

Art Writing Stories of Art(ists)

To be sure, the facts Passmore refers to here as foundational for critical and educational practice are nongeneralizable facts about individual works of art. But it is as ordinary for people to go ahead telling stories about artists as to continue to speak of the details of the artworks themselves. From antiquity both these practices have been equally commonplace.

Stories of artists are one of the two forms of art writing we have inherited with roots extending back to antiquity, the other form being the technical treatises written to guide artists in crafting certain desired effects. By no means are these stories afterthoughts or recollections, for they often circulate during artists' lifetimes and help to constitute the cultural context in which the artists' art is made and esteemed. From Pliny to Irving Stone, stories of artists' lives typically are cast as heroic narratives, relating how the artist faced and resolved personal, social, or artistic problems (typically all three kinds besiege the heroic artist) through innovating or excelling in, or obsessing about, making art.

Thus, Pliny relates how Apelles (*Natural History*, XXXV, 95), suspicious that his competitors had bribed the judges of a horse-painting competition, arranged to have some horses visit the competition. These incorruptible innocents whinnied at Apelles' depictions but ignored his competitors' horse paintings. This will be recognized as yet another variation on the tale Plato tells about Apelles' predecessor Zeuxis, whose work deceived humans while his competitor's bamboozled only birds. Or to illustrate further with another customary type of story about artists—that which has them abandoning ordinary comforts to serve their art—a nineteenth-century painting called *Van Dyck Being Led away from His Fiancee by Rubens*, by Luigi Rubio, shows Van Dyck reluctantly abandoning a weeping woman as he is dragged by an evidently affluent Rubens toward the door, and thence to his studies in Italy.

Stories of artists have been and remain central to learning about art. A century ago, as well as more recently, stories of artists' accomplishments served as interpretive introductions to the artists' art. Thus, an 1899 volume called *Barbara's Heritage, or Young Americans among the Old Italian Masters*[9] takes up the familiar story of how Cimabue discovered Giotto both herding and drawing goats. This narrative is expanded heuristically into an account about how Giotto, a peasant, was so much better attuned to nature than his better-educated predecessors that he naturalized Italian paintings, setting the stage for the Renaissance masters.

To take another example, in a monograph privately printed in 1914, Kenyon Cox, who was pivotal in introducing modernism to America, relates that Homer distanced himself from other painters:

> (When he spent ten months in Paris) he did not go into the schools, he did not copy old or modern masters, he did not settle in any of the artistic colonies or consort much with other artists, (and, much later, after Homer moved to Maine), almost any other man would have retained a studio in the city (and) almost any other man would have taken some pains to maintain his relationship with his brother artists and to keep in touch with what they were doing.[10]

Impelled by the contrast between Homer's secluded life and Whistler's urbane one, Cox goes on to argue that the former, not the latter, is the progenitor of that self-reliant style which is the only distinctively American one in virtue of its expression of the sturdy, independent character that results in clear vision.[11] To Cox, Whistler is "the brilliant cosmopolitan . . . whose art is American only because it is not quite English, and not quite French, and the sturdy realist (Homer) who has given us the most purely native work, as it is perhaps the most powerful, yet produced in America."[12] But this is not merely a chauvinistic observation, for it is in their difference of character that Cox locates what he takes to be the differences in the character of their art: the decadence of Whistler, whose minimalism "sloughed off" commonplace vision until just "a vestige of painting" remains, and the contrasting vigor of Homer, for whom form is represented integrally in, not abstracted from, representation of the commonplace look of the world.[13]

Here the artist's character is integrated with the artist's art. Closely related to this application of the artist's story is the revisionist recasting of an artist's history as a vehicle for revaluing the artist's art. For example, to propel the painter Artemisia Gentileschi from obscurity to luster, the art historian Mary Garrard reworks the chronology of her paintings so they illustrate the story of a woman heroically painting protests, tenuously at first, then forcefully, against the brutalization to which men subject women.[14] Elsewhere I have published relatively expansive analyses of how hero(in)ic art historical narratives are instrumental in revising the artistic canon, especially where these histories address feminist and multiculturalist concerns.

So I will not pursue further discussion of this practice here, but will return to Artemisia's case where it becomes relevant further on.[15]

Can Aesthetic Experience Be Pure?

Purging the experiencing of artistic value of contamination from schooling is supposed to distance it from the accidents of personal history. This is the objective of modern thinking about art, which since the eighteenth century has sought universality in the detachment of the experiencing subject. Effective art, it is thought, should transcend differences of culture and learning—that is, should appeal transculturally or internationally.

Thus, art's power is supposed to derive from how well it accords with human nature in general, not with particular humans and their specialized histories. A corollary encourages us to expect that the capacity to relish art can be activated even at a very early age, as the relevant experiences are essentially human ones and as such are not relativized to socialization or acculturation.

Recently, however, the innocent eye itself has been reproached for being no more than an artifice of educated taste. Isolating art from worldly contexts impersonalizes it, but also depersonalizes it by stripping away recognition of individual histories and affiliations. Also, arguably, impersonal transactions can be activated only from a position of equal or greater power, for subordination heightens the threat of being obscured, making depersonalizing standards more fearful.

Moreover, autonomy of judgment is reserved for the privileged. For a threshold condition for achieving autonomy is that one enjoy at least minimal recognition as a distinct, and therefore potentially independent, entity. Dependent beings are precisely those who are considered indistinct because inseparable from their attachments and, as such, they do not qualify as autonomous.

Carolyn Korsmeyer's observations summarize the feminist version of these objections very well:

> . . . the greater abilities of abstract reason drift to the "masculine" side of things, (and) the "cognitive" capabilities of the eyes and ears are carried in the wake. And the "bodily" senses of touch, taste, and smell remain grounded in the feminine. . . . Hearing and sight are elevated. . . . for the additional reason that they appear less intimate with the body and are more "distant" . . . it is only the more distanced objects of hearing and sound that provide the foundation on which the fine arts build. . . . This elevation of certain senses as . . . capable of delivering a purely aesthetic enjoyment is closely tied to theories of aesthetic experience dominant since the eighteenth century.[16]

Feminist theory denies that detachment is objective and real. Korsmeyer continues:

For years theories of the aesthetic were based upon the idea that purely aesthetic perception or attention is free from interest, desire, or any moral or practical concern. . . . The ostensible purpose of this approach is to rid the perceiver of individual idiosyncrasies, making possible a universal standard of taste set by a neutral, disinterested perceiver. But feminist analyses have built a convincing case . . . that interest . . . lurks within all perception . . . far from referring to a neutral perceiver, disinterested pleasure evidently presumes a gendered subject, who theorizes beauty in a way that . . . (keeps) him master of all he surveys.[17]

Two claims entwine here: one characterizes aesthetic properties, features directly present to sight and sound, as masculine because sight and sound are associated with mind rather than body; the second characterizes these same properties as masculine in virtue of their remoteness. Yet there is no biological bias gifting males with more sensitive hearing and more acute sight. And connecting mind more than body, or being remote instead of being intimate, with men seems a product of social arrangement, artificial and mutable rather than natural and invariable. Women are not naturally physical rather than cerebral, nor sociable rather than aloof. Though it sometimes is argued that they must be so because of the position they naturally assume in child-rearing or in love-making, how these roles are executed in practice is so plainly the product of class and culture as to be adopted or imposed.

It is one thing to recognize that perfectly detached experiences of art are fictitious, and that attaining such detachment is a desideratum no more free of social history than are more obviously social values. But it is quite another to specify how social context links into experiences of art. How we think art is produced, both in broad outline and specific detail, emerges as the conduit between a work's immediate perceptual impact and its indirectly apprehended context.

Earlier, I described my encounter with this phenomenon in the puzzling case of Vincent's happy bourgeois life. What was puzzling in this case, we may recall, was how a compelling narrative was able to dominate direct perceptions of art, even among perceivers who rejected such influence as inappropriate, and even absent their believing the story to be true. A comparable process not unlikely induces us to embrace the characterization of pure aestheticism as male.

In virtue of an explicitly narrated context in which the production of artifacts is supposed to further the interests of dominating males, perception fixes the characteristic features of modern aesthetic artifacts—especially those features which accentuate abstracted, idealized, detached, or removed form—as masculine. Feminist theory illuminates this context, and its enlightenment is diffused through perception and authorized by the traditional [hero(in)ic] histories of how individual works have come to be.

These overwhelmingly cast dominating males as protagonists, whether as artist or patron or other centrally activating agent. Thus they make feminist analysis credible and also encourage its application. For between seeing an object as being made by a man for a man, and seeing it as being made from and for men's interests, lies the barest of intervals.

How What We Learn Changes What We See

How do words about art make us perceive it as good or bad, rewarding or disagreeable, unblemished or tainted? Two distinctive and distinct positions have emerged in the philosophical literature to explain how this occurs. On one, words that generalize or abstract are assembled into principles and applied to artworks. Thus the works' features are assigned value and through the *mediation* of words are experienced as valuable. This account is promoted from Aristotle at least to Beardsley.

On the alternative account, words that particularize or singularize cause our attention to be directed to individual artworks' meritorious and defective aspects. Thus through the *intervention* of words the works' features are experienced directly as valuable. This account is promoted from Hume at least to Isenberg.

Although commonly thought to be poles apart, these two accounts of the work of words about art form a common front against the use of stories about artists to valorize art. For whether artistic value is appreciated immediately, with reason intervening only to expedite direct experience, or whether reason serves as an intermediary between the perception of a work and the appreciation of its value, effective critical reasons are taken to refer to art only, not to the artists who made the art. On both these accounts, critical reasons pick out valuable (or defective) parts of the work itself. Consequently, the familiar philosophical analyses of critical reasoning consign words about artists to irrelevance and condemn those whose perception of art reacts to words about artists as, at best, distracted.

In defense of these accounts, it may be hard to see how beliefs about context can have any function in fostering critical appreciation. For one thing, the facts of personal and social history attendant on an artwork's being made are incremental only. No links between the facts of art's production and its value seem sufficiently systematic to ground either the prediction or the explanation of aesthetic or artistic valuation. Indeed, the only confirmable rule here seems to be that every example elicits a counterexample.

Moreover, we more securely read a work's character as distinctive of its originator or originating culture—for instance, the Renaissance's revivified interest in naturalistic painting as showing the redemption of science during this period—than we read from a culture's preoccupations to the character of its art. Even the art historian John Berger, who contends that the

medium of oil painting historically has served as a tool to promote the system of property-owning, does not propose that oil painters are predominantly from the property-owning class or, for that matter, predominantly from any other economic class. Instead, Berger insists that oil painters, whether rich or poor, constitute a subservient class whose function is to create pictures portraying property-owning in a favorable light. Berger thus delineates the class relevant to his analysis by reference to features of the works its members turn out. He relies on his analysis of the paintings, not of their context, to make his thesis plausible.[18]

This observation bears on those feminist views which argue from repressive context to unjustifiably neglected content. At best, acknowledgment of repressive contexts clarifies why a work may heretofore have been discredited, but it seems to offer no illumination of what, if anything, about the work rewards regard.

More of Vincent's Story

Nevertheless, we have seen that one kind of learned context—cultural baggage consisting in acquired beliefs about the makers of art—can infuse the appreciative perception of art. That this is so applies both in extending artistic traditions and in revising them, for as we have seen stories about artists are used both to inculcate appreciation and to revolutionize it. But we have not yet considered the conditions that permit a work's context to pervade experience of the work itself. A case in which context fails to do this will provide some illumination.

Consider the famous 1888 Van Gogh painting of his bedroom in Arles. Vincent writes about this painting:

> Colour alone must carry it off, by imparting through simplification grander style to things, it should be suggestive of rest and sleep in general. In other words, the sight of the picture should rest the head, or the imagination. . . . The shadows and modeling are suppressed. . . . This will contrast, for instance, with the diligence of . . . the Night Cafe. . . . No stippling, no hatching, nothing, flat areas, but in harmony.[19]

Gombrich, who cites these sentences from Van Gogh's letters, asks whether the painting communicates this feeling of calm and restfulness. Gombrich remarks that none of the naive subjects he has asked have hit upon this meaning. Although they knew that the painting depicted Van Gogh's bedroom, they lacked the context and the code, Gombrich explains.

But Gombrich's first proposal is too narrow, and his second too broad, to explain why viewers do not understand the painting of the bedroom at Arles to be suggestive of rest. Gombrich writes as if the painting has a meaning that viewers would understand but for their innocence of Van

Gogh's code. Yet, it is byzantine to construe the *absence* of stippling and hatching, together with the *suppression* of shadowing and modeling, as a code.

Codes are learned as sets of signs together with their referents. Presumably one would not learn the meaning of a sign—for instance, that "#" is the code for "a"—by contrasting it with another sign—for example, "$". Learning a code requires learning something beyond the symbols themselves. This being so, Van Gogh's comments about shadowing and modeling are inconsistent with their being a code. For Van Gogh urges that the harmonious feeling of his pictured bedroom at Arles may be comprehended not by looking beyond the painting but instead within it, at the use of shadowing and modeling in the depiction of the frenetic atmosphere of the *Night Café*. Gombrich's thought is that seeing Van Gogh's 1888 depiction of his bedroom as restful involves deciphering. However, this seems too straitened a construal to explain how we might recognize the character of the painting.

On the other hand, Gombrich's alternative appeal, the reference to context, verges on being vacuous. It cannot be the case that simply to know the originating context of a work is to know the work's character as well. What kinds of contextual elements could be so intimate and simultaneously so compelling as to infuse perception of the work?

Resolving the Puzzle

To begin with, it is worth noting that proposals that link the context to the character of the work causally or otherwise contingently or empirically are dubious. For one thing, a disparity looms between what evidence suffices to confirm that claims about a work's context are factual, and what is needed to establish that claims about the work's character are factual.

My Van Gogh puzzle case, recounted earlier, illustrates this. Not the least puzzling aspect of that case proved to be that one's learning of my deception was not strongly correlated with recovering one's former appreciation of his painting. That is, the truth or falsity of my narrative seemed to be marginal rather than pivotal in influencing appreciation. The discovery that evidence preeminent in one's having abandoned moral or scientific beliefs is false surely would not be so pallid a restorative. (This is by no means to say that truth and falsity are of no importance in the history of art, but only to acknowledge that other elements in this discourse enjoy at least equal weight in determining how influential any claim will be. This heuristic point is of importance in considering what techniques are effective in art education.)

Mary Garrard's previously cited revision of the valuation of Artemisia's art reveals another barrier to tying descriptions of an artwork's originating context to characterizations of the artwork itself. Garrard magnifies the

significance of Artemisia's choice of subjects, which other commentators dismiss as routine. Garrard recasts Artemisia's pedestrian choices of scenes to paint by presenting them as an ingenious device Artemisia uses to camouflage her expressions of anger at having been raped, an expression which, if blatant, would have made her paintings socially unacceptable and unsalable in a male-dominated society.

An asymmetry is evident between Artemisia's rape, which is a documented historical fact, and her purported painted response to rape, which if it is a fact is of quite a different kind. The story establishing the documented facts must be shown to be relevant to the facts of the painting, for not all the artist's circumstances, just those attendant on the making of the artist's art, are so. Yet the process for verifying the historical facts is so different in kind from that for establishing the artistic facts that it is hard to see how historical facts can be linked to artistic facts as cause to effect through confirmable causal correlations.

Artemisia's rape is relevant to her history just in virtue of its having happened to her, but it is relevant to her art only through the additional demonstration that it is manifest in her paintings. This suggests that expressive characterizations of art cannot be reduced to descriptions of how or why the works were created. The difference lies in how these sorts of facts are to be established. We need not personally have witnessed her rape, for the transcript of the trial of her assailants documents the historical event that happened to her person. On the other hand, only by directly perceiving the evidence of her rage and anguish in her paintings can we become convinced that her rape is also a circumstance of her art. So documentation of her history as an artist, as distinct from her history as a person, lies in her works themselves.

This discussions suggests that we turn to a distinction introduced by several contemporary philosophers, notably Kendall Walton[20] and Jenefer Robinson,[21] between historical persons and art-historical persons. This philosophical view reinforces a thesis proposed early in the 1960s by the literary theorist Wayne Booth.[22] To comprehend how art writing about artists operates, let us apply these scholars' suggestions to the problem of sorting relevant from irrelevant circumstantial historical evidence.

We may consider the artistic protagonists of stories about how particular artworks came to be made to be constructs. These function as the implied or apparent creators of their works. The constructed artist's properties are qualities of art such as expressive attitudes, attributes of mind, character traits, and other aesthetic qualities that also can pertain to real persons, says Robinson.[23] By apprehending the configuration of the features of a work as purposeful rather than accidental, Walton thinks, we view them as the product of an artistic agent.[24] A reduction is central to this analysis, but

here descriptions of how or why the work was created are reduced to characterizations of the work itself.

This suggests another way words pervade our experience of art, one quite distinct from the two familiar to us from the usual philosophical literature. Instead of merely referring to preexisting properties of a work, this kind of critical reasoning helps compose certain properties by depicting artistic creators whose features are their works' features. Here critical reasoning is less judgmental than it is originative.

When these aesthetic attributions compose a coherent and distinctive set, they are treated as constituting a personal style idiosyncratic of their artist. If they are not coherent, they fail to form a protagonist whose story can be told. If they are not distinctive, there is no individuated artist.

The role of this constructed protagonist is to function within the context of art-historical or art-critical narration, where what is related is why and how valuable properties were incorporated into the artist's art. Aesthetic theory grounds coherence by suggesting which attributes enable creators to make art that is valuable. Art history grounds distinctiveness by suggesting what attributes distinguish a particular artist from other creators. Incidentally, telling this sort of story can promote revaluation of a work by drawing attention to merit that has been neglected or underestimated or underesteemed.

Precisely which events should constitute a narrated plot is, as is often remarked, a matter of the interpretive design of the whole story.[25] And it also is often pointed out that realistic narrative relies on the skillful deployment of convention: for instance, on the use of storytelling techniques which compel audiences to accept one interpretation without even considering others, or else on the employment of story sequences so conventional as to make interpretation (almost) automatic. It is desirable, perhaps even definitive, that historical accounts bear the marks of realistic rather than fictive narrative. And the condition of their being understood to be realistically historical is just that they are embedded in markedly conventionalized narrative.[26]

Teaching Arts Creative Contexts

We now are positioned to elucidate part of the puzzle that arose in the course of telling Vincent's story. Let us recall how curiously more compelling are the alterations in aesthetic perception induced in persons with purportedly "innocent" or "naive" eyes by my false story than by Gombrich's true story about Vincent.

This difference is paralleled by another contrast between my story and Gombrich's. By embedding my fiction within a familiar convention (*"New*

York Times announces scholarly discovery upsetting standard historical accounts"), I minimized interpretive dissonance. My coherent, albeit fictitious, narrative presented a calculating protagonist dissimilar to the familiar hero of Vincent's story, but my use of the "shocking discovery" conventions absorbed or deflected any shock.

Gombrich, on the other hand, failed to do more than interject a dissonant element—namely, a depiction of an artistically calculating Vincent—into a preexisting narrative that famously casts Vincent as expressive in virtue of being out of control. By amplifying rather than reducing incoherence, the historical facts Gombrich cites fail to become constitutive of Vincent's artistic character, which is in effect the character of the artist's art. Because they are highlighted as singular instead of camouflaged by convention, Gombrich's reported facts are sufficiently disruptive of our learned characterization of Vincent to be rejected rather than integrated into how we experience his work.

To summarize, however innocent one's eye, it seems, learned context possesses the potential for pervading one's direct perceptions of art. Such influence need not be exerted through the application of aesthetic principles or the presentation of historical interpretations. Nor can it always be detected by inducing viewers to articulate the aesthetic theories or historical background that impel their judgment. On the other hand, conventionalized narratives of artistic production bring aesthetics and history to bear on particular works of art because these ground, and thus inform, artistic characters that are perceived as the characters of the works themselves. Moreover, the most effective of these narratives are so contrived as to camouflage the force of their intervention.

Because artworks are, in a sense, the ultimate artifacts, it is possible that we cannot contemplate them absent accepting some story about how they were made. So diffuse is this practice that its grip may be inescapable. We have seen, at least, that even adherents of the innocent aesthetic eye fall unknowingly under its sway. Be this as it may, at the very least, as we have observed, telling stories of artistic production is an ancient and extremely widespread, indeed a global, phenomenon.

Thus, despite their lack of formal education, youngsters cannot be prevented from having acquired cultural baggage, in the form of beliefs about creative production or the production of artifacts, which will influence their experience of art. As we have seen, even belief in the innocent eye is an acquired allegiance. If presented with an artwork without a creation story attached to it, youngsters may be expected to supply a story of their own, one whose elements are drawn from their prior exposure to cultural values and practices. The characters composed in this way become the experienced characters—that is, the styles or meanings or excellences—of the artworks the youngsters perceive.

Teaching art thus may require intervention to modify or enhance or displace a work's perceived artistic character as this has been constructed by youngsters from their available cognitive stock and experienced by them as integral to the art they encounter or make. To be effective in doing this, teachers of art thus need more than knowledge of art itself—that is, of how to make it and of how it has been made. It is advisable also for them to build a wide repertoire of stories about art and to master as well the conventions of such storytelling.

In this essay, we have come to see that stories of artists are not peripheral to how we experience their art. Earlier, I commented on the longevity of the practice of art writing stories about how artistic protagonists excel. But it is not only the European art-making tradition which engages in this practice. Stories of artistic heroes are common to the great art traditions. (Incidentally, Japanese art history is of particular interest in supplying many stories of leading female artists and developing several art forms where women took the lead as innovators.) But many other cultures tell similar stories of artists, such as Pacific Coast Native American carvers who pass down stories of their ancestors' greatest creations long after those wooden works have rotted away, and Native Australian chanters who narrate which ancestral innovators introduced new dimensions to chanting.

If what I have argued here reflects the facts, even the most innocent eye cannot help but perceive art in ways influenced by culture or class or by other interests served when we tell each other stories. Far from being artificially occluded by elitist or repressive social structures, aesthetic experience adjusts to this kind of learning naturally, although artful storytelling about art greatly facilitates the process. Elsewhere, I have shown how narrating the history of artistic figures like the eighteenth-century African American poet Phillis Wheatley effectuates the integration of tradition and innovation.[27] By applying the perspective offered in that essay and this one to the art of such bicultural figures, teachers can take advantage of the natural ways we learn about art to further their commitments to multiculturalism and diversity.

NOTES

1. The puzzle case method helps people to become aware of their own conceptions about art. This method is developed, with sample puzzles and supporting materials, in *Puzzles about Art*, coauthored by Margaret Battin, John Fisher, Ron Moore, and Anita Silvers (New York: St. Martin's Press, 1989).
2. Immanuel Kant, *Critique of Judgment*, trans. J. H. Bernard (New York: Hafner Press, 1951), p. 152.
3. Ibid., p. 163.
4. Ibid., pp. 147-48.
5. Ibid., pp. 161-62.

6. Patricia Clahassey, "Modernism, Post-Modernism, and Art Education," *Art Education* 39, no. 2 (March 1986): 46.
7. John Passmore, "The Dreariness of Aesthetics," in *Essays in Aesthetics and Language*, ed. William Elton (Oxford: Basil Blackwell, 1959), p. 37.
8. Ibid., pp. 53-54.
9. Deristhe L. Hoyt, *Barbara's Heritage, or Young Americans among the Old Italian Masters* (Boston: W. A. Wilde Company, 1899).
10. Kenyon Cox, *What Is Painting? "Winslow Homer" and Other Essays* (New York: W. W. Norton, 1988), p. 19, pp. 31-32.
11. Ibid., p. 18.
12. Ibid., p. 7.
13. Ibid., pp. xxiv-xxv.
14. Mary Garrard, *Artemisia Gentileschi: The Image of the Female Hero in Italian Baroque Art* (Princeton, N.J.: Princeton University Press, 1989).
15. See my "Has Hero(in)e's Time Now Come?" which foregrounds Artemisia's story, in the *Journal of Aesthetics and Art Criticism* 44, no. 4 (Fall 1990): 365-79. Also see my "Pure Historicism and the Heritage of Hero[in]es: Who Grows in Phillis Wheatley's Garden?" *Journal of Aesthetics and Art Criticism* 51, no., 3 (19): 475-82.
16. Carolyn Korsmeyer, "Gender Bias in Aesthetics," *American Philosophical Association Newsletter on Feminism* 89, no. 2 (Winter 1990): 45-46.
17. Ibid.
18. John Berger, *Ways of Seeing* (New York: Penguin Books, 1977), pp. 83-112.
19. Cited in Ernst Gombrich, *The Image and the Eye* (Ithaca, N.Y.: Cornell University Press, 1982), p. 161.
20. Kendall Walton, "Style and the Products and Processes of Art," in *The Concept of Style*, ed. Berel Lang (Philadelphia: University of Pennsylvania Press, 1979), pp. 45-46.
21. Jenefer Robinson, "Style and Personality in the Literary Work," in *Aesthetics: A Critical Anthology*, ed. George Dickie, Richard Sclafani, and Donald Roblin (New York: St. Martin's 1977), pp. 455-68.
22. Wayne Booth, *The Rhetoric of Fiction* (Chicago: University of Chicago Press, 1961), passim.
23. Robinson, "Style and Personality," p. 465.
24. Walton, "Style and the Products and Processes," pp. 45-56.
25. Cf. my treatment of how art-historical narrative integrates tradition with innovation, "Pure Historicism and the Heritage of Hero(in)es."
26. The compact account of the features of narrative relied on here is derived from a summary made by Jerome Bruner in "The Narrative Construction of Reality," *Critical Inquiry* 18, no. 1 (Autumn 1991): 1-21.
27. See my "Pure Historicism and the Heritage of Hero(in)es."

Aesthetics for Children: Some Psychological Reflections

ELLEN HANDLER SPITZ

> When art is made new, we are made new with it.
>
> —John Russell, 1981

This essay is addressed principally to teachers who wish to incorporate aesthetics into their work with children.[1] It presents a child-centered approach that might be considered an adaptation of what Margaret Battin, John Fisher, Ronald Moore, and Anita Silvers have persuasively advocated in their work with college undergraduates, namely, a "case-driven" method that confronts students with "puzzles about art."[2] The examples in this essay, however, stretch that approach beyond cognition to engage other focal aspects of children's functioning and accord a rôle to psychosocial needs, developmental imperatives, and emotional requirements. These variables, while recognized as ever-present and significant, are viewed not as restrictive or censorious but as factors to be kept in tacit awareness, a context never to be dismissed.

Work with young children in the arts always involves a tension between the desire to allow charged material to challenge and stimulate—to churn still waters—and the sober requirement that young minds be protected from what they may not be ready to negotiate—that children be able (emotionally and intellectually) to swim before being given the signal to jump in. Care in titrating these two legitimate aims matters most, of course, with the very youngest children. Older ones, preadolescents, vary considerably in their capacity to handle experiences in the arts and culture, and a reliable study of the relevant variables would constitute a valuable contribution to the literature.[3]

In the first experiment described here, a list of observed psychological assets and vulnerabilities was drawn up by the consultants but set to the

Ellen Handler Spitz is an independent scholar and lecturer in aesthetics and psychiatry associated with Cornell University Medical College. She is the coeditor of *Freud and Forbidden Knowledge* and the author of *Art and Psyche, Image and Insight,* and of recent articles in such journals as *The Psychoanalytic Review* and *PostScripts: Essays in Film and the Humanities.*

side. Assuming the children in the program brought natural curiosity and inventiveness, as well as naïveté, we thought it best to avoid imposing predetermined problems, tasks, or even specific works but sought rather to provide an atmosphere conducive to discovery. As will be seen, this guiding principle led to projects veering off in unexpected directions and to group dynamics that occasionally took on the semblance of those red, blue, orange, and yellow, boisterous, confusing, but energetic bumper car rides at amusement parks. The risks, however, proved worth taking, and a certain quantum of chaos is probably endemic to authentic encounters with the unfamiliar, with art in particular, and with the realm of the aesthetic.

This essay highlights two experimental programs undertaken with elementary-school-aged children at a public school site in suburban New York.[4] Neither is offered as a paradigm to be replicated, nor are they delineated in full detail; rather, they are meant to demonstrate a general approach to aesthetic education. Occasional theoretical comments aim at broader issues, namely, the growing aesthetic awareness of children and the rôle of aesthetic education for development more generally. The underlying premise in both examples is that the developmental imperatives of children cannot be ignored, but that, within the limits of any given situation, supreme priority should be given to welcoming the unexpected and allowing wonderful ideas[5] to emerge from the needs, competencies, and predilections of individuals. Curriculum was conceived as a bolt of cloth to be jointly chalked, cut, and fashioned by teacher and students rather than as a pattern ready-made.

The "Seminar" Program

"Seminar" was a program in aesthetic education targeted for "gifted" fifth and sixth grade children who had been selected on the bases of test scores, classroom teachers' impressions, interviews, and writing samples. It was apparent to the consultants[6] nevertheless that the resulting group was remarkably heterogeneous. We believed that any randomly selected group of children could have fared equally well given similar opportunities. Despite, however, the many differences and great variety of talents and abilities displayed by individuals,[7] we observed widespread adaptive strategies as well as emotional and social vulnerabilities.

These particular ten- and eleven-year-old girls and boys were unusually high in energy. Many possessed an irrepressible and sophisticated sense of humor, and all had the ability to concentrate intensely. On the less positive side, we noted instances of the following: (1) feelings of social isolation, that is to say, of loneliness, shyness, a sense of being different from others; (2) excessive competitiveness that occasionally led to feelings of unworthiness and even to a bitterness rather than pride when other children excelled; (3) occasional underachievement that seemed to stem from past experiences

of having won praise after only minimal expenditures of effort; (4) a prematurely narrowed focus of interest that was often encouraged by parents who had a tendency to typecast their talented child, as, for example, a musical prodigy; (5) a diffuseness or inability to pay attention manifested now and then by a child who seemed to be marching internally to a different drummer and thus unable to conform to the pace and direction of the group; (6) rapid oscillations between independent and dependent behavior, a trait we noted primarily in certain very bright girls, who seemed ambivalent about success, distrustful of their capacity to make decisions, and petulant in their excessive bid for peer validation and teacher approval;[8] lastly, (7) overachievement, a straining for perfection brought on perhaps by a particular child's self-worth being so bound to his or her performance level. All of these traits, nascent and ebbing, might be subsumed under the heading of an imbalance, a lack of integration, among the intellectual, the emotional, and the social spheres of development. Again, however it is worth emphasizing that while such imbalances may afflict bright children with particular intensity, they are a part of every young person's journey from infancy to adulthood.

Through aesthetic education, we sought to ameliorate these *aporias* by providing a milieu that would engage children in a holistic way and thus forge links between their different spheres of competence. We held this to be possible because we saw the realm of the aesthetic as an opportunity for risk taking, pattern making, and dreaming up as well as solving problems. We saw it as an arena for the integration of past and present, a chance to experiment with enactment, elaboration, variation, interpretation, and critical evaluation. We saw the arts also as a source of powerful models for the children's future selves and behavior.

Taking the aesthetic then as a site of new ways of ordering human experiences and perceptions, we sought to evolve a flexible, integrative curriculum in aesthetic education that would not *cover* but *discover* its own subject matter. To engage the children in many dimensions, we planned to introduce and integrate work in the visual and language arts and the performing arts of drama and dance.

About thirty children culled from the total fifth and sixth grade population of one elementary school[9] participated in this year-long venture. Divided into two groups, each met weekly in separate sessions with the two participating consultants. Whereas at first we worked independently while maintaining close communication through meetings and via telephone, our coordination meshed ever more closely until toward the end of the year joint sessions were held, and for the culminating event the groups came together, as will be described. Facilities included natural light, movable furniture, water supply, display areas, and ample space for both activity and storage.

Our initial task, we felt, was to forge group esprit and foster a basic sense of trust among the children (who at first did not all know one another) and ourselves. This trust was vital, we knew, to a climate where mutual self-discovery and creative risk taking could flourish. To promote it, we hit upon the broad theme of *identity*. Not knowing quite where that would lead, we saw as one possible objective the relative distancing of each child from his or her own egocentricity and the gaining of insight through projection into an imaginary character. We supposed that imaginary characters might concretize wishful aspirations on the part of individual children as well as instantiate partial opposites or doubles. Taking up, then, the notion of character portrayal in theater, we thought first to consider its visual aspects and devised exercises on this theme. The children posed and modeled in costumes for each other and then wrote about their responses to these newly formed costumed characters.

Surprisingly, the elements that sparked their interest and elicited their most telling responses were not, as we had expected, the obvious aesthetic properties of the garments per se, namely, their colors, textures, or symbolic associations, but rather the children's fellow classmates' poses, facial expressions, and their awkward or studied manners as they wore the unaccustomed regalia. Interpreted along the lines of psychoanalytic psychology, this phenomenon made perfect sense. Human response to the external world invariably begins with projections of a rudimentary bodily self.[10] To grasp this and to understand the children's reactions in light of it is to acknowledge the rôle played by primitive projection and identification in the process of aesthetic development as well as in the growth of knowledge more broadly conceived. The other children's faces and bodies were, in this exercise, just one remove from the children's own faces and bodies, but now in the strange process of becoming defamiliarized. They—that is to say, the postures and contortions of their peers—were therefore noticed and found fascinating: they evoked the first authentic identifications and projections. The costumes per se, on the other hand, to which we had expected them to react with gusto, may have seemed initially just too remote to elicit comment.

Starting at this point then, we wondered how we might urge our group of children to go beyond their first move. How could we get them to notice more, extend their perceptual and imaginative range, refine their first impressions? We did not want to *tell* them, nor to *direct* their gaze. This posed the next educational challenge. We thought up some new exercises in which yards of fabric of varied texture, color, and pattern could be used, in and of themselves, to motivate a scene or drama. Several children chose a filmy white chiffon and dramatized a story that took place in a dressmaker's shop. Others selected a large swath of bright-crimson, heavy-woven cotton and enacted scenes involving horsemen in a chase with a mad dog. A third group chose pink grosgrain silk to drape around themselves in a scene of

nasty conflict between two wealthy sisters. In each of these instances, we saw with interest that it was now clearly the visual and tactile aspects of the material that appealed to the children and to which they were able to respond imaginatively. Thus, a different level of aesthetic response seemed here to be called in play.

Movement and mime seemed a natural follow-up, and the children readily transformed themselves into clowns, robots, rock stars, thieves, basketball, baseball, and tennis champs, a prisoner, and a tightrope walker. As they created these characters through movement alone, they expressed a dawning awareness of the extreme reliance in our culture on the spoken word. Many children expressed frustration at not being permitted to speak while performing, and we explored these feelings in group discussions afterwards. Parenthetically, it is worth nothing that, since our goal was to keep each activity as open as possible, we made a strict rule that experience should precede discussion; we encouraged verbalization only after an activity had actually been tried. Here, our theory was that experimentation in the realm of the aesthetic should follow the path of human development itself, as well as the dictates of the O.E.D., which defines "aesthetic" as "things perceptible by the senses, things material (as opposed to things thinkable or immaterial)." We believed that to talk first would be to foreclose empiricism but that to talk afterward would be to forge important links between deed and word, the concrete and the abstract—links children often need help in forming.

Mime exercises sharpened the children's perception of the expressive possibilities of gesture and walk and gave insight into the specific types of movement that can be used consciously or unconsciously to express a personality or a mood. We discussed different acting techniques. They began to discover they were able, when a character or two appeared onstage and even before any words were spoken, to tell a great deal. Just by noting the elements of posture, gait, and bodily mannerisms, they could predict something about possible relationships and even have a premonition of plot.

Characterization through mime led to other exercises in which the children mirrored each others' actions. These proved excellent for inducing intense concentration as well as frequent outbursts of uncontrollable giggles. The children worked in pairs, one as the initiator of an agreed-upon character's action while the second served as a precise mirror. At some point, while performing for the rest of the group, these rôles would imperceptibly reverse, and this had to be done so that the audience could not distinguish the initiator from the imitator of the action. The challenge of this work was highly pleasurable to the children, who chose such figures to represent as a blind person, a clown putting on his makeup, and various sports figures. Any ice between individual members of the group had by now thawed,

although hot undercurrents of competitiveness were still occasionally in evidence. We felt the children gained much from serving as audience to each others' efforts. Aesthetic education involves learning how to function as the member of an audience; and although this is a complex rôle in our culture, with both private and public aspects, it is one we tend to take, insensitively, for granted.

During our discussions, several children spoke about trust—their need for confidence in the leader of an activity, the person in control, and their even greater need for trust when the possibility of verbal language has been foreclosed. This theme continued during sessions devoted to "silent group conducting," in which one child would lead the rest of the class in movement by indicating only through her own motions what she wanted them to do. Experimenting with the power of nonverbal communication, each conductor learned how to guide the other children in whatever direction, tempo, degree of tension or release he wished to achieve and in the general mood he sought to elicit. Later, children evinced their greater understanding of the need for theater and movie directors, choreographers, and orchestra and band conductors to win the trust of their respective companies and to communicate clearly in order to achieve integrated performances.

Emotion as a motivation for movement was the emphasis of another exercise and one that elicited a great variety of response. Having asked the group to come up with an emotion and then act it out, we found that, whereas some children could respond freely to the cue of a word, an abstraction, others needed to be primed with a concrete situation. An example was "joy." Some children were able to take off from the mere idea and jump or clap, spin, leap, hug each other, and so on. Others felt they had to be provided with a concrete instance, for example, winning a contest or a race, receiving a longed-for present, finally arriving at a place they had always wanted to visit. In discussing the differences they felt between responding to an abstract concept such as fear, grief, or anger and responding to a specific situation, the children taught us that the ability to function on an abstract plane cannot be correlated in any simple way with a more or less sophisticated level of aesthetic response.

A special bonus for the "Seminar" project was its link with the Lincoln Center Institute, a well-known program in aesthetic education that has been ongoing in the New York metropolitan area since the seventies. During the course of our work, a modern dancer, Andrew Quinlan-Krichels, came on three occasions to prepare our children for viewing specially repeated performances of Anthony Tudor's ballet *Little Improvisations*. His approach to space and movement complemented and extended the children's ongoing mime and improvisation work, so that their eventual pleasure in the winter performances was greatly enriched.

Concurrently with the work I have been describing, the children were

engaged in individual long-term projects, namely, the elaboration of characters of their own imagining in the medium of collage. These personae emerged gradually as life-sized figures done on a backing of heavy brown paper and executed with a variety of materials, including fabrics, ribbons, buttons, tinfoil, paint, ink, chalk, lace, yarn. Each character was given a name (which in a few cases changed more than once!), and then a dramatic monologue was composed for him or her. By tape recording, the children were able to experiment with the problem of refining their texts and vocalizations in order to fit ever more closely the characters' visual representations. Some went further and teamed up in small groups to experiment with inventing plots, dialogues, and scenes involving several characters. They read short stories to each other in preparation for this work, and I read to them as well—principally poetry chosen for its masterful portrayal of character.[11] Also, in conjunction with our exploration of the rôle of character in literature, I read them Edgar Allan Poe's "The Telltale Heart" and excerpts from Alan Sillitoe's "The Loneliness of the Long Distance Runner." Despite technical setbacks, the children in the program all had a chance to tape-record their monologues or plays and to view sight/sound presentations in which 35mm color slides of their characters were screened in synchrony with the tapes.

By this time it became apparent that our collage character project had begun to overlap ongoing work (initiated by the second "Seminar" consultant, Edith Kleiner) on Shakespeare's *Julius Caesar*. Engaged in close reading of the play with a special focus on character revelation and interaction, the children began to generate an endless stream of questions about life and culture in ancient Rome. As we listened and tried valiantly to answer their earnest queries, we sensed the possibility of an element of aesthetic education we had failed to consider. Thanks to our bright young students, we began to see the inescapable need for research. Not having anticipated this in our initial plans, we now saw that the cloth was truly being patterned by the children's own needs and desires. What evolved next was a meshing of our work on dramatic character with their fascination with the culture of ancient Rome.

Each child at this point assumed a Latin name and became a character of that ancient society—a particular general, statesman, poet, doctor, architect, cook. We amassed a wealth of materials, books, reproductions, slides of ancient Rome and its arts. Rôles were researched, and we read Livy's account of the founding of Rome. At their prompting, I began to teach them Latin by encouraging them to initiate the vocabulary they wished to learn. Whereas much of our previous work had emphasized the nondiscursive arts, verbal language now came into sharp focus. Treating Latin as a living language, the children began to use it orally as well as in written form and to frame simple phrases concerning family, home, school life, and friends.

Grammatically, we stayed with the present tense of verbs and avoided the subjunctive. After several months, many children could translate a stanza or paragraph and were becoming increasingly sensitive to the derivation of English words and to grammatical structures in English. Their joy at this mastery was contagious, and eventually parents and siblings reported being addressed in Latin! We composed short plays based on favorite myths, *Androcles et Leo, Arca Pandorae,* and *Midas Rex.*

Individually and in small groups, the children experimented with Roman art media. Depicting themes drawn from their research or from *Julius Caesar* or taking up simple decorative motifs, they worked in mosaic tiles, painted large murals in the "Pompeian manner," created columns in the different orders, sculpted miniature scenes in plasticene, and even insisted, after hearing Pliny's account of the eruption of Vesuvius, on devising a way of building a minivolcano capable of being detonated. Psychologically, the spin-off from this flurry of activity was beyond our most extravagant expectations. Group esprit flourished. Cooperation was at a height. Each person's interests broadened, and concentration and focus were observable wherever one cast one's eye. Children also began to point out references to ancient culture in the world around them—in advertising, on television— and to note discontinuities between ancient and modern practice, with respect, for example, to gender. Parenthetically, amused at how well their naïve intoxication with discovery preserved them from the self-conscious scruples of postmodern scholars who suffer tormenting doubts that they will ever truly understand the past, we felt, in our case, no such scruples. Permitting the children the full range of their aesthetic inebriation, we comfortably left such worries to be conferred upon them, whenever, by future educators.

The end of the year approached precipitously, and we suddenly realized that, although our emphasis had all along been on process rather than product, a culminating event could not be avoided. The children wanted at this point to do something spectacular and together. They came up with the idea of a gala Roman banquet to which they could invite family and guests. Organizing themselves, they galvanized into action, prepared authentic foods, built an altar for the requisite libation to the gods, made elaborate decorations and costumes, and practised for hours both in and out of school a variety of entertainments designed to utilize their own special artistic gifts in myriad ways. Two young trumpeters, for example, were to provide a fanfare, a budding gymnast to perform for the assemblage in the guise of a slave girl, a small, self selected troupe to offer what proved to be a hilarious, original mime version of the Romulus and Remus story, and our three short plays to be performed in Latin along with scenes from *Julius Caesar.*

Evaluating the experiment as a venture in aesthetic education, we felt pleased. Managing to cling tenaciously to our mission of following wherever

the children themselves had been leading or at least of sharing the compass with them, we had not—except temporarily—actually lost anyone. Awareness and sensitivity to the arts had surely increased and intensified during the year for most children in the program, and many had emerged more relaxed and companionable than they had appeared at the outset. Along with the blossoming of a fresh enthusiasm for live drama and dance, for poetry and visual arts, we noted new close friendships, increased self-confidence, and a sense of community fostered, we believed, by shared experiences in so many modalities. The goal of aesthetic education in children, I gleaned from this experiment, ought not be conceived as the transmitting of any preordained content; rather, it might be taken as, first and foremost, the nurturing of curiosity, wonder, and an ongoing impetus to become more alive to one's own perceptions as well as to the perceptions of others and to the infinitely expanding and nuanced world of sense and feeling.

Our experiment was limited; it yielded no formulas. It did not include in any important sense, for example, the art of music, nor were theoretical problems addressed as such, that is to say, philosophically. It followed an unpredictable trajectory emanating from its own peculiar blend of teachers, students, and setting. Others can and indeed *must* find alternative approaches to their own agreed-upon agendas, whether multidisciplinary (like ours) or more narrowly conceived. In each instance, however, despite rough spots, failures of nerve, and myriad frustrations, the energy, ebullience, knowledge, and growth that can ensue will prove abiding in value for the children (and adults) involved.

Museum/Child/Interact

This program, unlike "Seminar," involved several hundred children, virtually an entire school population.[12] Our goal here—given strictures of time, limited resources, pressure of numbers, and the usual resistances to contemporary art—was to enable young people to forge meaningful links of their own with the emerging art of our epoch and to foster a sense of continuity between their creative efforts and the work of exhibiting artists.

The challenge of the program was to prepare children of different ages and backgrounds for viewing a particular exhibit, but to do so in age-appropriate experiential terms rather than, as is usual, by imparting (verbal) information. We did not want, for example, to *name* any of the artists in the exhibit in advance nor give out any external data (biographical, historical, technical). We wanted the children to enter the museum with whatever preparation they might have gained through the hands-on experiences we devised for and with them and then to be surprised. For practical reasons, Museum/Child/Interact had to be more controlled than the year-long "Seminar" project. We wanted the children to puzzle over *why* an artist

creates and *how* a visual artist talks to us without using words. We actively set up and encouraged (1) moments of slow, careful gazing unfettered by ordinary utlitarian concerns; (2) dialogues, including struggles, with materials; and (3) deep immersion in the related processes of *art making* and *art seeing.* Our overriding credo was strict avoidance of advance information about the exhibition. *Seven Artists* was to appear to the children after a month of work that, according to our hunch, might prepare them more authentically than any lecture could.

The educational challenges were manifold: to put across the notions that visual art is made for the *eye,* and yet not just for the eye but also for the entire body and sense of self through the medium of *space* (both measurable and imaginary)—that an artist's work can fill and transform whatever space it happens to be sharing with us; that (and how) visual art communicates with us through a sensuous language of its own; that art has to do with revelation and the shifting limits of the possible, that it exposes much that is weird and wonderful, terrible and beautiful, in the most ordinary aspects of life; that making things counts just as much as the things finally made, because making things is actually making oneself; that to play with materials and put something together out in the real world—something new, something that was never there before—is to function like an artist.

After researching forthcoming shows at local museums, I selected promising exhibits at the Neuberger Museum in Purchase, New York. Located on the grounds of the State University designated specifically as an arts campus housing departments of theater, dance, and music as well as visual arts, this site allowed us to introduce an interdisciplinary component into what was essentially a visual-arts-oriented program. In fact, each trip to the museum did eventually include observation of dance classes, tours of the campus theaters (including a blackbox), and student-led visits to working art studios.

For the younger children (first through third grades), the exhibit we selected, *Seven Artists,* included two- and three-dimensional and installation work by American artists all born in the decade of the forties.[13] Extremely diverse, all of these artists manifested a commitment to process—to openly intuitive approaches, to improvisation, and to manifest pleasure in spontaneity.[14]

The program design provided for an intensive six weeks with each group of children. First, the consultant was to observe each participating class in session and chat with teacher and students. The goals of this low-key encounter were psychological and practical: to establish basic contact, to gain some initial feel for the style and mood of each milieu (e.g., more or less formal or informal, warm or distant, rigid or relaxed), to introduce the general aims of the program, to request materials, and to answer questions. Three following sessions then were to be devoted to participatory work on the part of students, consultant, and, importantly, each classroom teacher.

To transform ordinary space temporarily into an art space, each teacher and group of students were asked to clear wall and exhibition room. Our rationale was that this would afford an experiential convergence between the realm of the aesthetic and that of the children's ongoing daily life and curriculum; in addition, we felt it would enable both teachers and students to feel at home in the presence of new sights, ideas, and objects. Thus, as the aesthetic education progressed, each group found itself increasingly surrounded by a visual, material environment that reflected its own artistic efforts. Parenthetically, long afterward, many participating classrooms retained these special art spaces and kept them as an ongoing part of their educational ambience.

Simple materials were requested, the theory here being that lack of technique ought not restrict expression nor impede experimentation. The fifth week was to be a culmination of the previous month: a full day's trip to the Neuberger Museum to view the *Seven Artists* exhibit as well as to observe live arts activities on campus. Finally, the sixth week was planned as a follow-up session, a reprise with 35mm color slides and discussion (evaluation) in the school auditorium.

As in the "Seminar" program, participatory exercises were devised, and each of these proved of varying value; highly significant variables seemed to be the developmental stage of the children involved and the general tenor of their particular classroom setting. With regard to looking, one early activity required the children to close their eyes while sequential and incremental small changes were made in their environment. Gradually, they grew more adept at identifying these changes. In a subsequent exercise, they were asked to imagine they had just landed in a spaceship from another planet and that everything in their surrounds was therefore now utterly foreign to them. They walked slowly around their room—noticing, touching, examining familiar objects that had suddenly become incomprehensible. Selecting one that seemed special for whatever reason, they each made a detailed drawing of it to take back on the spaceship to show their families. The children's goal here was to make such a well-observed drawing that their families in outer space would feel that they too had actually seen the foreign object.

After talking briefly about this exercise, they contributed next to a joint mural—a long paper taped to the wall, to which each in turn added a line or a shape in response to all that had previously been done by others. This furthered the notion of visual communication, and a follow-up to this proved highly pleasurable for many groups. Choosing partners, the children held silent conversations (and arguments) on paper entirely in terms of visual language (line, color, etc.). Although no explicit correlation was made in advance with *Seven Artists*, one special connection we were hoping would emerge was with the biomorphic abstract paintings of Gregory Amenoff.

Donald Lipski, a gestural artist with roots in *dada*, had contributed an installation to *Seven Artists*, a work called *Passing Time 1980*. This consisted of nearly 200 sculptures made by binding, braiding, folding, wrapping, and winding an assortment of discarded materials such as old mismatched boots, ledgers, skates, paint brush handles, tubing, and obsolete keys to gallery walls and floors. A tinkerer, he had collected his finished sculptures in shoe boxes and then transported them to the gallery where he did his own installation—on ceiling and floor as well as on the canonical walls. To prepare the children for his work (but of course unbeknownst to them), we asked them to find a shoe box of their own and to collect assorted small objects they found were being discarded but that appealed to them in some way. After amassing worn building blocks, wire, ribbons, used film, batteries, match box covers, and the like, they discussed the difficulty of classifying these objects into categories such as rough/smooth; round/sharp; soft/hard; shiny/dull, and we talked about how their looks, their shapes, and their sizes might be altered as well as about how some might be joined with others. Employing glue, string, tape, scissors, pliers, wire cutters, they busily tinkered, and at length arranged their newly created objects in space, thus cooperating in the formation of a joint installation of their own and experiencing the way in which their self-fashioned sculptures, rescued from trash and debris, revitalized the classroom and reorganized their space. Eventually, some of the children asked to bring their own sculptures to the museum, and their responses to Lipski were among the most gratifying of all.

Each of the seven artists was approached in a similar manner, and the children's responses to the show when they encountered it in the museum seemed to reflect a level of connectedness we believed unattainable otherwise. We observed an unusual degree of comfort, ease, sense of familiarity and "friendliness" between these children and the exhibited objects. In the follow-up sessions, we asked them to consider the difference between really being there, with the art, and just seeing the slides now back at school. Rather than address this, however, most of the children preferred to take the occasion as an opportunity to remember—to treat it as a pleasurable return, a reprise of what had been a thoroughly enjoyable experience for them, to talk about what they had especially liked (and disliked) in the museum. With several classes, we experimented with group poems (taken down, in the case of the youngest children, by their classroom teacher as scribes on one large sheet per group). We said: *Make* us know how you feel: "I *must* tell you . . ."

Recently, in a lecture sponsored jointly by the Harvard Graduate School of Education and Divinity School, psychiatrist Robert Coles summed up his attitude to the education of children in words that ideally suit the approach

I have been advocating here with respect to aesthetic education. I should like to conclude this essay with them: "Education," said Coles, "is being shaken up, derailed from those tracks we get onto, with all the certainties, sometimes the false certainties, they offer us—the stages, phases, cycles, categories, definitions, mandates, rules—marching us through anything so that we tame uncertainty, ambiguity, and contradiction—the very stuff of life."[15]

NOTES

1. In thinking about aesthetics and children, I have benefited from contacts with many extraordinary people. Three individuals, however, taught me that one *could* cut critically to deep levels of psychological truth while keeping in play the rippling surfaces of art and human perception. To them I owe a special debt of gratitude: Rika Burnham (dance), Randy Williams (visual art), and Ruth Alperson (music). I also wish to acknowledge my gracious colleagues, Edith Kleiner and Catherine T. Theoharides, and, above all, the children who made reality out of fantasy with us.

2. Margaret Battin, John Fisher, Ronald Moore, and Anita Silvers, *Puzzles about Art: An Aesthetics Casebook* (New York: St. Martin's Press, 1989).

3. Concern with, and debate over, this issue arises periodically in the press. In *The Washington Post*, for example, a recent article reported that, a propos of Steven Spielberg's violent fantasy film *Jurassic Park*, apparently the director himself stated that he would not take his own young children to see it (see Joel Achenbach, "Blood. Guts. Mayhem. Cool!" 28 June 1993, pp. B1, B10). *The New York Times*, moreover, a few days later, published a front-page story on attempts by Congress to impose controls on television violence, presumably in large part because of its effects on children ("Mild Slap at TV Violence," by Edmund L. Andrews, 1 July, 1933, pp. A1, A14).

4. Both programs took place at the William B. Ward Elementary School, City District of New Rochelle; principal: Catherine T. Theoharides. The "Seminar" Program ran during 1979-1980; "Museum/Child/Interact" ran during 1980-1981. The former was summarized in my "An Interdisciplinary Approach for a City System: Aesthetic Education for the Intellectually Gifted Child," in A. Hurwitz, *The Gifted and Talented in Art* (Worcester, Mass.: Davis, 1983). The latter was outlined in "Museums and Children: A Natural Connection," *Journal of the New York School Boards Association* (May 1981), and in a *New York Times* article entitled "Museum Modernizes Tours for Children," by Judith Wershil Hasan (2 November 1980).

5. This notion is borrowed from a well-known article by Piaget's associate, Eleanor Duckworth, "The Having of Wonderful Ideas," *Harvard Educational Review* 42, no. 2 (May 1972): 217-31.

6. The consultant-teachers in this program were myself and Edith Kleiner, an artist born in South Africa.

7. For an excellent study of multiple forms of giftedness, see Howard Gardner, *Frames of Mind: The Theory of Multiple Intelligences* (New York: Basic Books, 1983).

8. On this topic of girls' differential needs for relatedness and affirmation, see Carol Gilligan, *In A Different Voice: Women's Conceptions of the Self and Morality* (Cambridge, Mass.: Harvard University Press, 1982); and Nancy J. Chodorow, *Feminism and Psychoanalytic Theory* (New Haven, Conn.: Yale University Press, 1989).

9. See n. 4.

10. In addition to Freud's famous dictum that "the ego is first and foremost a bodily ego" (in "The Ego and the Id," 1923, *Standard Edition*, vol. 19, p. 26), there is a fascinating literature on the ways in which children take their own bodies directly as a model for constructing the world. I have written on this in *Art and Psyche* (New Haven, Conn.: Yale University Press, 1985), and a marvelous example is offered by the Hungarian psychoanalyst Sandor Ferenczi in his 1912 paper, "Symbolism," where he reports that a little child, shown the Danube for the first time, saw it as an enormous stream of spit (see *First Contributions to Psycho-Analysis*, tr. Ernest Jones [New York: Brunner-Mazel, 1952/1980], p. 279).

11. These included: "Richard Cory," by Edwin Arlington Robinson; "Lucinda Matlock," by Edgar Lee Masters; "A Song in the Front Yard," by Gwendolyn Brooks.

12. For logistic reasons only, the principal decided to exclude the oldest (sixth grade) and the youngest (kindergarten) children.

13. See exhibition catalogue, *Seven Artists*: Gregory Amenoff, Eleanor Hubbard, Bill Jensen, Donald Lipski, Bruce Robbins, Judith Shea, Lynn Umlauf. Neuberger Museum, State University of New York, College at Purchase (5 October 1980 through January 1981).

14. A second exhibit (chosen for viewing by fourth and fifth grade youngsters) featured the work of Nancy Graves—her camels, bones, maps, and camouflage paintings. See *Nancy Graves: A Survey 1969-1980*, Essay by Linda L. Cathcart (Buffalo: Albright-Knox Gallery, 1980).

15. Quoted by Tom Gardner in "Moral Energy in the Young," *The Harvard Graduate School Alumni Bulletin*, June 1993, p. 24.

A version of this essay entitled "Welcoming the Unexpected" will appear as a chapter in the author's forthcoming *Museums of the Mind*. The permission of Yale University Press is gratefully acknowledged.

Aesthetics and the Art Curriculum

MARILYN GALVIN STEWART

> I consider pictures like the one above art because art is an expression in your mind put some way for other people to see. So if this is an expression from someone's mind, then it has to be art. Not all pictures made by a computer can be called art. Some pictures made by a computer aren't someone's expression and are not their imagination.
>
> —Kim Wagaman

This was the position taken by Kim Wagaman, a fourth-grade student in Oley, Pennsylvania, when her art teacher, Jeff Dietrich, showed her and her classmates a computer-generated drawing of Grant Wood's *American Gothic* and asked them if they considered the picture and others like it to be art.[1] He also asked them whether they thought all pictures made by computers are art. Another student in the class agreed with Kim, stating that the picture is art because "it wasn't exactly made by the computer. It had to be put into the computer. All the computer did was store the image." A few others said it was art because "it was made to be looked at as art." Claiming that "just about anything can be art," one student referred to the art of a contemporary artist whose work consisted of what he referred to as "a pile of rocks." There were some detractors, like the student who said the computer picture was not art because "there is no natural talent in it. The real way of painting would be forgotten (if art could be made by computers)."[2] All of the fourth graders had been engaged in a discussion of computers and art before being asked to write their thoughts on a worksheet prepared for their comments. Engagement in discussions such as the one about computers is a regular occurrence in this teacher's classes, where students often are asked to think, talk, and write about philosophical issues.

Art Linkletter reminded us that "kids say the darndest things."[3] Some of us remember the segment on his television show in which we took delight

Marilyn Galvin Stewart is Professor in the Department of Art Education and Crafts at Kutztown University, where she recently served as Associate Provost. She is currently writing a text on aesthetics in the curriculum and has most recently published an essay in *Inside Art: Teacher's Guide* and a review article in this journal.

in the often insightful and more often humorous things that kids on his show would say. But like participants on most TV shows of this sort, the kids were supposed to be "cute." They auditioned for the roles and got them because they were likely to say something that would delight the viewers. They were essentially actors.

The students in Jeff Dietrich's class were not assuming roles as they considered the question put before them. These were their own positions, and they took them seriously. They had been engaged for several weeks in a unit on Regionalist art. They had seen the work of Grant Wood, Thomas Hart Benton, and others, had interpreted those works, had spent some time attending to the era in which the artists were making art, and had considered the roles that artists can play in expressing ideas and feelings about their world. In the course of their time with this art teacher, these same students also had been asked to think about art in general and to begin to develop their own definitions of art.

When they were asked to reflect upon the computer-generated image, they were able to return to some of their prior experiences with many different works of art, with their previous attempts to define art, and with other works by Grant Wood. It is clear from the response by Kim Wagaman that she had had some experience in developing lines of reasoning. Her words appear to have been chosen carefully as she put forth her argument. She apparently understood that she needed to clarify her position regarding computer-generated pictures, distinguishing between "all" and "some" works. Kim's responses, along with those of other members of the class, are more than "cute," childish responses. They demonstrate that kids can think, talk, and write philosophically, they can develop sound reasoning skills, and they can do this in the context of studying art.

That engagement with art can be a catalyst for raising philosophical questions about the nature and value of art and our experiences with it is amply demonstrated in the works of Western philosophers from Plato forward. In addition, those of us who have taught art in the schools know that our students often wonder why certain works have merit and others seem not to, why some people are considered artists while others fail to gain the distinction, what the processes of making and viewing art involve, and so on. Students struggle with these questions, with varying degrees of sophistication, at all grade levels in school. They have been doing this for a long time. In recent years, however, increasing attention has been given within the field of art education to the ways in which such philosophical questions can be addressed when they are raised by students. Further, there has been attention paid to ways in which teachers can *plan* for philosophical discussions with their students.

This increased attention has followed a widespread emphasis on Discipline-Based Art Education (DBAE) wherein it is recommended that the

study of art include art-historical inquiry, art criticism, studio production, and aesthetics.[4] Of these four areas of inquiry (probably due to the multiple uses in art education of the term 'aesthetics'), the aesthetics component has been most resistant to formulation in terms of concepts, skills, and attitudes—subject matter—to be addressed within the art curriculum. In an effort to overcome this difficulty, several aestheticians have outlined the various philosophical questions and concepts central to their discipline, and several art educators have worked to translate the key concerns of aesthetics into viable strategies for teaching.[5] Although art educators might still deal with these topics as issues of aesthetic perception, awareness, or as something vaguely related to style in art, they increasingly discuss aesthetics as a branch of philosophy and refer to engagement in aesthetics as philosophical inquiry.

Aesthetics has been taken into the classrooms by teachers, many of whom have been involved with DBAE professional development institutes and workshops. It has been these teachers who have been largely responsible for incorporating the concepts and skills of philosophical inquiry into units of study and have discovered ways to integrate the content from the discipline into substantive learning experiences for their students. The process of gathering data from these teachers has been informal, at best, generally dependent upon correspondence and conversations. What is suggested by theoreticians and practitioners alike, however, is that the addition of philosophical inquiry to a sequential and balanced curriculum in art is a significant way of fostering a reflective and meaningful engagement in the study of art.

Philosophical inquiry fosters meaningful engagement because it helps students conceptually organize their experiences with art—their experiences in making art as well as their experiences in historical and critical inquiry. A child's experience of art can be cluttered with particulars—clearly a helter-skelter world of artworks, processes, concepts, understandings, and ideas. Like the philosophers who attempt to organize the world of particulars into coherent, synoptic frameworks, children need to organize their experiences with art through sorting, categorizing, establishing and discovering connections, and finding differences in order to establish their own frameworks for understanding. One reason philosophical inquiry is significant for children engaged with art is that it provides a means for such organizations.

But philosophical inquiry has other merits. When students are asked to think about the nature of art by considering such things as the ontological status of pictures made by a computer, they are moved to probe the conceptual structure through which they understand the world. In the process, distinctions are made, connections are seen, and often new questions emerge for attention. The process is enhanced by conversing with others

who, in similar attempts to make sense of experience, articulate their beliefs and present reasons for holding them.

Sometimes students find that their frameworks beg to be altered. New categories are added or old ones extended. Sometimes deeply embedded beliefs are exposed as false, or at least as resting on shaky ground. Even when beliefs remain unchanged, students are more aware of their reasons for holding them. If others have been involved in the process, students may learn that there are reasonable alternative positions. What is additionally significant about this process is that students learn that things are not always as simple as they seem, and that attention to seemingly minor issues can clarify one's own assumptions and beliefs. As they learn to listen to and carefully consider the views of others, children may be willing to approach the world less dogmatically. Assuming that there is a certain satisfaction in owning one's ideas, students may be disposed again to wonder about, question, and give focused attention to their art-related lives. In the end, they may become more reflective and better skilled in thinking about their lives in general. These lessons learned through engagement with art are educationally relevant in the broadest possible sense.

Learning Outcomes in Aesthetics

It is a mistake to think of aesthetics as one more burdensome component to be squeezed into an already tightly packed art program. Philosophical issues and questions arise naturally and invite serious attention when students are actively engaged in the study of art—creating and reflecting upon their own artworks and considering cultural, historical, and art-critical issues associated with their own art and that of others. Teachers need to recognize that philosophical issues may arise without their planning for them and be prepared to address them. In addition, there are concepts, skills, and attitudes associated with the discipline of aesthetics which, once learned, can contribute to a student's overall understanding of and fulfilling engagement with art. Learning outcomes in aesthetics can be identified in general terms for a K-12 program. These outcomes can be stated with increasing specificity as one moves from the program level to the grade, unit, and lesson levels of study. In an attempt to provide experiences in aesthetics as an integral part of the study of art, teachers can plan units and lessons in which issues in aesthetics become the major focus of or a component of a unit or lesson. The following general learning outcomes for aesthetics, which include knowledge of concepts, skills, and attitudes, are posited for consideration.

Generally, students will know that

1. individuals tend to wonder and ask questions about the nature, significance, and experience of art and beauty;

2. individuals develop beliefs about the nature, significance, and experience of art and beauty;
3. careful use of words, statements, and reasons can help individuals reflect, talk, and write about their questions and beliefs;
4. careful reflection can result in beliefs being changed;
5. philosophers explore questions about art and beauty and their experiences with them and construct explanations, or theories, to address these questions.

With respect to skills of philosophical inquiry, students generally will know how to

1. reflect upon their beliefs about the nature, significance, and experience of art and beauty;
2. listen carefully to others' points of view;
3. select and evaluate carefully the use of words, statements, and definitions to make general statements about the nature, significance, and experience of art and beauty;
4. carefully present and evaluate reasons in support of their positions;
5. use the above skills to engage productively in philosophical inquiry alone or with others.

Given knowledge of the above, students will have certain attitudes, tendencies, and propensities, such that they will be inclined to

1. inquire into the nature, significance, and experience of art and beauty;
2. value their own beliefs and reasons for holding these beliefs;
3. appreciate the enterprise of offering and assessing reasons;
4. seek and respect alternative views about philosophical issues.

Drawing from these general outcomes, teachers can formulate specific learning objectives for integration with units and lessons of study.[6] These objects should take into account the developmental capacities of children, their prior knowledge of, experiences with, and questions about art, as well as other considerations of sequence—what parts of the whole might logically follow others.[7] Knowing how to listen carefully, for instance, is a prerequisite for reflecting upon the statements made by others. Teachers can design strategies grounded in art content that help students develop their listening skills. In the early years, teachers might give the students rough categories drawn from distinctions made by philosophers and others, which serve as ways of helping students to reflect upon and organize their own thinking. Over time, students are provided opportunities to examine these distinctions, critically assess their appropriateness, and develop new ones believed to be more appropriate. With careful sequencing, students will progress in their ability to analyze and construct distinctions, definitions, and value statements and can be encouraged to develop theoretical perspectives of their own. Although familiarity with the theoretical perspectives of particular philosophers or other theoreticians ought not be seen as

an end in itself, it can serve as a catalyst for refinement of the students' own perspectives. When considered holistically, the inclusion of aesthetics in the K-12 curriculum provides students opportunities to construct and test their own ideas about key philosophical issues raised, encountered, and addressed within the study of art.

Instructional Strategies for Teaching Aesthetics

Perhaps the most important way in which teachers can help students construct frameworks through which to understand their art-related experiences is to establish an environment where inquiry is valued. Teachers need to encourage rather than suppress discussion of philosophical questions as they emerge. They must also help students learn how to reflect upon and present their own views and to consider the views of others. In addition to allotting time and establishing an appropriate environment for the discussion of philosophical issues, opportunities for the development and refinement of critical thinking skills must be provided.

In an environment in which questioning is valued, students will feel comfortable raising philosophical questions. The challenge for the teacher often is to determine when it is appropriate to engage the whole class or possibly a small group of students in a philosophical discussion.

Spontaneous Questions and "The Big Questions Chart"

The art classroom is often full of activity, with students working on various studio projects, requiring assistance as they go about their work, and with the teacher moving around the room, attempting to address the various needs of students as they emerge. At other times, small and large groups of students are engaged in critical and historical inquiry. When students are engrossed in making and thinking about art, they are apt to think about their experiences in general terms. Philosophical questions which emerge rarely can be adequately addressed with simple, clear-cut answers. Ideally, a teacher would take advantage of the interest evidenced by such thinking and questioning and provide opportunities for students to sort through problems or issues as they arise, but it is not always practical to do so. When time and other constraints preclude discussion at the moment a question is raised, philosophical questions might be placed on a "Big Questions" chart on display in the room. This chart serves as a reminder that there are important questions to consider about our experiences with art. Further, having such a display might encourage students to consider one or more of the questions alone or in small groups in or out of class. Time can be set aside at a later date to conduct a class discussion about issues noted on the chart. While not addressed immediately, the philosophical question is validated as a serious one, one that merits consideration. As students become

experienced in adding philosophical questions to the list, the chart helps to create and maintain an environment hospitable to inquiry arising from a serious study of art.

Planned Discussions

Employing a variety of strategies, teachers can plan for philosophical discussions within the curriculum. In addition to arranging for time to address questions remaining from other class times, teachers can plan for discussion of questions or issues associated with a particular unit of study. Teachers can anticipate questions or issues stemming from engagement in art-making activities or from engagement with certain artworks or themes. The lesson in which students in Jeff Dietrich's class considered computer-generated images of *American Gothic*, for instance, was tied to a series of lessons in a unit on Regionalist art and a previous unit on computers and art and a series of discussions prior to completion of a worksheet. Games, role-playing, worksheets, and other familiar strategies can be employed to elicit responses to philosophical questions. In addition, teachers can plan for discussions by employing strategies such as those which follow.

1. The Use of Philosophical Puzzles. Philosophical issues are often at the heart of community debates about public art, specific exhibits, or special events. The installation of the Viet Nam Memorial in Washington, D.C., for example, spurred a flurry of nationwide discussion about whether public art, or war memorials in general, should be representational or not. The large black wall was offensive to some who believed that the Viet Nam Memorial should look like the many other war memorials found on county courthouse lawns across the country. The widespread and prolonged interest in the appropriateness of the Viet Nam Memorial is but one indication that real-life situations can be philosophically puzzling. Teachers and students can look to the media for evidence of such debates and for associated philosophical problems. Editorials and letters to editors contain opinions based upon a variety of assumptions about the nature of art and its role in society. These assumptions can be noted and can serve as catalysts for discussion.

While the real world offers a wealth of philosophically interesting issues, teachers and students can create hypothetical situations that raise philosophical questions. The invention of such situations, or "cases," is a longstanding practice in philosophical inquiry and in the teaching of philosophy, and one that has been highlighted by several philosophers as a viable strategy for art educators wishing to engage students in the discussion of aesthetic puzzles.[8]

2. Great Debates. An effective format for philosophical discussion is one in which students assume different positions relative to a particular issue. Issues for debate might stem from engagement with themes or concepts or

from real or hypothetical "cases." Students argue for their own positions about the issue or for positions assigned to them in role-playing situations. Assuming roles of members of a museum board of directors, for instance, students might offer reasons for or against including a particular object or work of art in the museum collection. To aid students in presenting various points of view, teachers might distribute role cards upon which different beliefs or theories are explained. Role-playing also is effective when students are divided into groups in which all members of each group assume the same position. In role-playing, as students attempt to persuade others to accept the positions associated with their respective roles, they sometimes will be challenged to argue for points of view that are not necessarily their own. In the process of developing arguments, they will become more aware of their own views and develop an appreciation for the views of others.

3. *"In-Out-Maybe" Activities.* Commercially produced or handmade items of all types can be brought before the class as students consider whether these items have aesthetic value (In) or not (Out). After discussion, it may be determined that some items may have aesthetic value under certain conditions (Maybe). As with all group discussions, students must provide reasons for their views. This activity is especially intriguing when similar items are considered. For example, a piece of pottery made from a mold and found in great volume in a local discount store, a piece of pottery that is handmade but made in great volume for the tourist trade, and a piece of pottery that is handmade and unique will prompt discussion of such notions as originality, uniqueness, use, and intention when each is considered relative to its aesthetic value. "In-Out-Maybe" can be planned as a small- or large-group activity, can be used in conjunction with role-playing, or can take the form of an ongoing discussion centered on a bulletin board or display case upon which items or pictures of items are periodically placed.

Whether philosophical discussions are conducted spontaneously by addressing questions or issues that emerge during class or are prompted by returning to a question placed on a growing list, by arranging for classroom debates or other game-like situations, or by presenting students with real or hypothetical puzzles to consider, teachers need to recognize the classroom discussion as a pedagogical strategy in and of itself. As such, it requires serious consideration, not only in terms of getting it started, but also in terms of guiding it as it progresses and bringing it to a satisfactory end.

Facilitating Philosophical Discussions

Art education preservice programs have not always emphasized the role of the art teacher as discussion facilitator. Experienced teachers who are highly skilled in organizing studio activities often are hesitant, due to lack of experience in this area, to enter in class discussions. Although skill in fa-

cilitating discussions develops with practice, some remarks about conducting and providing closure to philosophical discussions are in order.

The teacher as the facilitator helps students formulate well-reasoned views about philosophical issues. The facilitator requires that students provide reasons as they state their positions and asks others to respond to what has been offered. Facilitating often involves summarizing the positions stated and offering related questions for consideration.

Good reasoning skills are modeled by the teacher who helps identify underlying assumptions, asks for clarification of terms, requests that students provide examples when necessary, and helps them make distinctions. There is no predetermined pattern for philosophical discussions, and sometimes the direction will shift away from the original question posed. New issues may be raised and addressed. The facilitator must judge when it would be or not be appropriate or helpful to move into another area for discussion. Judgments also must be made regarding appropriate closure.

Because philosophical discussions can be lively and engaging, it is often the case that the end of the class period comes before a "natural" end of the discussion. In order to address the pedagogical concern for providing closure, the teacher can help the students review the discussion as far as it has developed, noting the original questions, how the discussion progressed, what positions were taken, what new ideas were presented, and what new questions were raised. If there are two or more clear positions, these should be noted. The facilitator should emphasize that rational discussion can result in opinions being changed, and when they are not changed, participants can be more aware of their reasons for holding them. Students can be helped to understand that there are times when it is reasonable to agree to disagree—that some issues cannot be resolved because they are rooted in deeply held beliefs that do not seem able to be changed.

Reflection upon Philosophical Discussions

While every student is encouraged to enter into group discussions, it is likely that some students will remain quiet. All students should have the opportunity to reflect upon the discussion and upon their own views, regardless of the extent to which they were noticeably involved in it. In a journal devoted to "Thoughts about Art," for example, students can be asked to consider the discussion, noting statements made with which they agree and those with which they disagree. Students can be asked to indicate questions that they still have regarding issues addressed. If students know in advance that they will be required to write in their journals, they will likely listen more carefully. In addition, these journals provide a record of their own views and changes in these views over time.

Teaching Specific Concepts and Skills

Students learn the use of good reasoning during dialogues with the teacher who serves as a model and who, through questions and comments, requires the students to think carefully. Teachers also can teach reasoning skills directly, by providing activities and worksheets designed to address them. As part of its series of novels and dialogue suggestions, the Philosophy for Children[9] program includes worksheets and exercises for developing reasoning skills. The increasing focus in the literature on critical thinking has resulted in a proliferation of materials for teaching thinking skills. Teachers can adapt these materials to art-related activities that help students learn to identify assumptions, clarify and evaluate the use of words and statements, and construct and evaluate arguments. The task for art educators is to design activities such as these with a focus upon aesthetic issues. At times, art specialists and classroom teachers can work together to provide opportunities for students to learn the skills that will help them engage in philosophical inquiry. Again, sequencing objectives and instructional strategies in aesthetics is crucial toward the development of a substantive, balanced, discipline-based curriculum in art.

The Role of the Aesthetician

It is useful for students to learn something about philosophers and what they have said about art, about making and responding to art, about the role of art in society, about issues in criticism, and about aesthetic experience. Views of philosophers can be summarized for students to consider. Philosophers might be invited to meet and talk with students about their views and about aesthetic issues in general. The emphasis here is upon the aesthetician as a real human being who is interested in the kinds of questions students have when they engage in the serious study of art.

Conclusion

It is precisely because wondering about philosophical questions and issues is central to what it means to be a real human being who is exploring the meanings inherent in the activities of making and responding to art that aesthetics should be included as an integral part of the art curriculum. In planning an art curriculum that includes aesthetics as an area of inquiry, we can formulate learning outcomes at the program, unit, and lesson levels, and these outcomes can comply with most state and district general outcomes. Learning in aesthetics should be specified and sequenced throughout a K-12 program in art, while at the same time connected to inquiry in the other discipline areas of art production, art criticism, and art and cultural history.

In such a program, we should expect that Kim Wagaman, who in Jeff Dietrich's fourth-grade art class already has begun to develop reasoning skills that allow her to offer thoughtful responses to questions about the nature of art, will have extended and refined her views through repeated and increasingly sophisticated engagement in philosophical inquiry. By the time she reaches the end of her schooling, we should expect that she will be prepared to address thoughtfully and reasonably not only the challenges that new forms of technology and multiple meanings in art will provide, but also the challenges that will be presented by a rapidly changing social and political world in which she encounters and experiences this art.

NOTES

1. Jeffrey Dietrich, "Art Criticism Methodology for Grades Three, Four, and Five in the Oley Valley School District" (unpublished paper, Kutztown University, Kutztown, Pa., 1992), p. 17.
2. Ibid.
3. Art Linkletter, *Kids Say the Darndest Things* (Englewood Cliffs, N.J.: Prentice-Hall, 1957).
4. See, for example, Gilbert Clark, Michael Day, and Dwaine Greer, "Discipline-Based Art Education: Becoming Students of Art, *Journal of Aesthetic Education* 21, no. 2 (Summer 1987): 129-93.
5. See, for example, Margaret P. Battin, "The Contributions of Aesthetics," in *Research Readings for Discipline-Based Art Education: A Journey beyond Creating*, ed. Stephen Mark Dobbs (Reston, Va.: National Art Education Association, 1988), pp. 126-29; Donald W. Crawford, "Aesthetics in Discipline-Based Art Education," *Journal of Aesthetic Education* 21, no. 2 (Summer 1987): 227-39; Marcia M. Eaton, *Basic Issues in Aesthetics* (Belmont, Calif.: Wadsworth, 1988); and Anita Silvers, "Implications of Discipline-Based Art Education for Preservice Art Education," panel presentation, Seminar Proceedings, *The Preservice Challenge: Discipline-Based Art Education and Recent Reports on Higher Education* (Los Angeles, Calif.: The J. Paul Getty Trust, 1988).
 Work in this area also has been done by art educators. See, for example, Carmen Armstrong, *Aesthetics Resource: An Aid for Integrating Aesthetics into Art Curricula and Instruction* (DeKalb: School of Art, Northern Illinois University, 1990); Mary Erickson, "Teaching Aesthetics K-12," in *Pennsylvania's Symposium on Art Education, Aesthetics and Art Criticism*, ed. Evan Kern (Harrisburg, Pa.: State Department of Education, 1986); Mary Erickson, Eldon Katter, and Marilyn Stewart, *The BASIC Curriculum for Art* (Kutztown, Pa.: MELD, 1988); Sally Hagaman, "Philosophical Aesthetics in Art Education: A Further Look toward Implementation," *Art Education* 43, no. 4 (July 1990): 22-24, 33-39, and "The Community of Inquiry: An Approach to Collaborative Learning," *Studies in Art Education* 31, no. 3 (Spring 1990): 149-57; Louis Lankford, *Aesthetics: Issues and Inquiry* (Reston, Va.: National Art Education Association, 1992), and "Preparation and Risk in Teaching Aesthetics," *Art Education* 43, no. 5 (September 1990): 50-56; Michael J. Parsons and H. Gene Blocker, *Aesthetics and Education*, in the *Disciplines in Art Education: Contexts of Understanding* series (Urbana: University of Illinois Press 1993); Robert Russell, "The Aesthetician as a Model in Learning about Art," *Studies in Art Education* 27, no. 4 (Summer 1986): 186-97, and "Children's Philosophical Inquiry into Defining Art: A Quasi-Experimental Study of Aesthetics in the Elementary Classroom," *Studies in Art Education* 29,

no. 3 (1988): 282-91; and Marilyn Stewart, "Teaching Aesthetics: Philosophical Inquiry in the DBAE Classroom," in Seminar Proceedings, *Inheriting the Theory: New Voices and Multiple Perspectives on DBAE* (Los Angeles, Calif.: The Getty Center for Education in the Arts, 1989), pp. 43-45.

6. For sequenced objectives and strategies for instruction and evaluation, see Erickson, Katter, and Marilyn Stewart, *The Basic Curriculum for Art.*

7. Insights into how children develop beliefs about art can be gleaned from Michael J. Parsons, *How We Understand Art: A Cognitive Developmental Account of Aesthetic Experience* (New York: Cambridge University Press, 1987).

8. Margaret P. Battin, John Fisher, Ronald Moore, and Anita Silvers, *Puzzles about Art: An Aesthetics Casebook* (New York: St. Martin's Press, 1989).

9. For an account of the work conducted by the Institute for the Advancement of Philosophy for Children, see, for example, Matthew Lipman, Ann Margaret Sharp, and Frederick Oscanyan, *Philosophy in the Classroom* (Philadelphia: Temple University Press, 1980); Matthew Lipman, *Philosophy Goes to School* (Philadelphia: Temple University Press, 1988).

Cases for Kids: Using Puzzles to Teach Aesthetics to Children

MARGARET P. BATTIN

Aesthetics for Kids

Nothing stupefies kids (I have in mind young people, though the same is true of many adults) as quickly as long-winded, jargon-filled, highly abstract theoretical discourse, especially when it seems to have no immediate utility. Kids like fun. They like play; they like games; they like challenges and puzzles; and they detest pompous academic abstractions. But if this is so, then it is easy to understand why aesthetics—this most abstract, theoretical, and sometimes pompous field of the art-related academic disciplines—would seem completely unsuitable for teaching to children. After all, just picture yourself lecturing, say, on the aesthetics of Kant (skirting, of course, the full scholarly complexity of the *Critique of Judgment*), or on Santayana, or on Clive Bell, or any other major figure in the history of aesthetics—even if you try to buy relevance by jazzing it up with a couple of references to comic-book art or rap tunes—and you see a roomful of squirming, restless, utterly bored kids, eager for you to quit. Perhaps all you do is try to explain how some people think that art is the expression of feelings or that beauty is "really real"—but you still may get the same apathetic response. "So what," the kids will say, "who cares?"

But now picture a child faced with a genuine puzzle—a puzzle that does not depend on abstract terminology, scholarly tradition, or extensive background information, but a puzzle that presents a real problem, here and now. If you can get the child to see the puzzle so that it makes him or her think, you are in effect home free. With a bit of adroit guidance in the form of further, prodding questions, the child will do the rest—that is, try to figure the puzzle out.

It is this conception of young people and their intellectual capacities and interests that invites a new way of teaching aesthetics to children. The

Margaret P. Battin, Professor of Philosophy at the University of Utah, is the senior author of *Puzzles about Art* and the author of such recent books as *Ethics in the Sanctuary* and *The Least Worst Death* as well as of numerous articles and essays in the fields of ethics, bioethics, and aesthetics. She has also published several works of fiction.

conception is a consummately simple one: *kids like puzzles*, though they are often bored by history, scholarship, and theory; and hence an approach to aesthetics that presents its essential elements in puzzle form will be best-adapted to teaching them. This is the central feature of the approach explored here: the use of puzzle cases. It makes aesthetics for young people, well, fun.

Consider, for example, a puzzle case that might be presented in a children's art or art theory class, or any other class where aesthetics may be the topic:

Case 1. *The Case of the Chartreuse Portrait*

Al Meinbart paints a portrait of art dealer Daffodil Glurt. The resulting canvas is a single solid color, chartreuse. Meinbart hangs the canvas in the Museum of Modern Art, labelled "Portrait of Daffodil Glurt." Daffodil is not amused. But has she actually been insulted?[1]

Now the sly thing about a puzzle case like this, of course, is that the puzzles in it are all aesthetic ones. Will the kids think Daffodil Glurt has actually been insulted by Meinbart's all-chartreuse portrait? If so, how, exactly, was she insulted? The answer depends in part on whether they think nonobjective art can make assertions (e.g., "Daffodil Glurt is a prissy, sour woman") or not, though they are unlikely to use this terminology; and if they do think nonobjective art can make assertions, how can we know what these assertions are? The kids may think that a solid-color patch cannot portray or say anything. On the other hand, if they think it can say something—for instance, that Daffodil is prissy and sour—they may also wonder why it couldn't equally well say that she is a woman with the bursting energies of early spring, like yellow-green forsythia buds just as they break into bloom. Or that she has the intoxicating, pungent sweetness of a certain liqueur. And so on. Children are wizards at inventing things a solid patch of chartreuse might say, but in doing so they also see that it is difficult to say which one is right, or for that matter whether a solid patch of chartreuse says anything at all. At best, they may say, viewers may have varying emotional reactions to the alleged portrait, depending on whether they like the color chartreuse and how their moods are running that day, but these have nothing to do with any alleged claim about Daffodil Glurt that the artist might have made.

Imagine how the dialogue between teacher and student in the classroom might go; it will probably have a gently Socratic, argumentative flavor:

Teacher: (having just described *The Case of the Chartreuse Portrait*) . . . there, has Daffodil been insulted?
Student: You bet. That's an awful color. Daffodil's not chartreuse.
Teacher: Do you mean, you'd make her green, or orange, or some other color?

Student:	No. She shouldn't be just a color at all.
Teacher:	Is that because a portrait should look like the person it's a portrait of?
Student:	Yup.
Teacher:	How much like a person does a portrait have to be?
Student:	A lot. It has to look just like the person.
Teacher:	Would it have to be made of the same thing, flesh and blood?
Student:	Of course not. Then it would not be a portrait, but another person.
Teacher:	Would a photograph do?
Student:	Sure.
Teacher:	But a photograph is a flat surface, like the chartreuse patch. So is a painting. Will a painting do?
Student:	Of course. But it has to look like the person.
Teacher:	Suppose the face looks like the person, but she's wearing different clothes, say a costume? [Perhaps the teacher is thinking of some of Rembrandt's self-portraits]
Student:	Sure, that's a portrait.
Teacher:	Suppose the face looks sort of like the person, but it's distorted? [Now the teacher is thinking of Modigliani or Picasso, and perhaps showing slides of these works]
Student:	Well, those are still portraits, sort of . . .
Teacher:	Suppose it describes a person, but not in pictures, like a novel?
Student:	Yes, I guess you could call that a portrait of a person too. A novel sort of captures the flavor of a person . . .
Teacher:	Could a chartreuse patch capture as much of the flavor of a person as a description in words could?

(and so on)

Or the dialogue might instead go like this:

Teacher:	(having presented the case) . . . there, has Daffodil been insulted?
Student:	Nope. How can that even be a picture of her? It's just a plain color patch.
Teacher:	Is chartreuse a color you like? How does it make you feel?
Student:	Ugh. I don't like it.
Teacher:	But if it's a color you don't like, it probably makes you feel bad when you look at this canvas.
Student:	Yeah, I spose so.
Teacher:	But if it makes you feel bad, then won't you be a little more likely to feel the same way about Daffodil when you think about her, since it's labelled "Portrait of Daffodil Glurt"?
Student:	Hmm.
Teacher:	Does it make any difference that the artist named it "Portrait of Daffodil Glurt?" That he thought of it as a portrait, and so did she?

(and so on)

When a child explores these issues in this way, even with the help of a teacher, he or she is doing precisely what full-grown, adult aestheticians with Ph.D.s and university appointments do. Of course, full-grown aestheticians for the most part do it with an elaborate conceptual apparatus of abstract terminology, but the underlying issues are the same: the nature of representation, the identification of the artist's intentions, the possibilities of assertion in art. These are all issues central to aesthetics.

The Background Problems in Aesthetics

(If you're interested only in kids, skip this section; it's about aesthetics for grownups.) The case method presented here was originally developed for adult aestheticians and their students, not for children, though it appears to be particularly effective with children. The method was developed not primarily for pedagogical but for methodological reasons, to meet a problem that affects both the teaching and doing of aesthetics at the undergraduate, graduate, and professional levels. The problem, endemic in the field of aesthetics, is this: most of the time, when conventional aestheticians set out to work, either teaching in the classroom or exploring aesthetic issues, they begin in one of two ways. Either they begin with a theory—often a theory about what art or beauty is—and then they attempt to apply it to a specific, individual case. Or, on the other hand, they begin with specific, individual instances of art or beauty and attempt to subsume them under a theory. For example—to pick the very simplest sort of example—one can "do aesthetics" by beginning with expression theory (the view that art is the expression and transmission of emotion) and by then showing how the theory applies to poetry or painting or music—say, a Byron poem or one of the Van Gogh sunflowers or a symphony of Brahms. "See how effectively these works convey the artists' emotions," one might say, "you weep when you feel Byron's anguish in his poetry; you are made uneasy by the jarring, crazy tensions in Van Gogh's sunflowers; and you are tossed from despair to exultation and back again by the symphonies of Brahms!" Alternatively, in doing aesthetics, one could begin with a Byron poem or a Van Gogh sunflower or a Brahms symphony and then show how aesthetic theory illuminates what we read or see or hear. When we perceive Byron's or Van Gogh's or Brahms' work under the tutelage of expression theory, it might be said, we interpret these works as expressing and conveying their creators' emotions directly to us, and we perceive them much more sensitively and fully.

Much of the teaching of aesthetics is of the first form: it begins with the theory and then points to artworks that illustrate the theory (though when it is taught it is usually dressed in more sophisticated terminology). A good deal of art criticism within aesthetics, in contrast, is of the second form: it

begins with the artworks and then uses theory to understand and interpret these works. But, at least in principle, doing aesthetics in these two ways is *boring* (or, as John Passmore used to put it, "dreary").[2] It is boring not so much because the theories are often long winded and jargon stuffed (on the contrary, some aesthetic theories are quite exciting) or because the artworks selected are somehow deficient, but for a much more significant methodological reason. Operating in these ways risks being intellectually hollow, because neither strategy can really tell you very much. The root problem is that, in either approach, aesthetics tends to be *theory driven* rather than *driven to theory*; the issues with which it is concerned are a product of the demands and deficiencies of its theoretical constructions, not issues made pressing by the subject matter itself. To expound a theory and then illustrate it by pointing to one or another work of art may, indeed, illuminate the theory, but it does little to tell you whether the theory is true: this is because the works selected to illustrate the theory are not selected at random, but are chosen *because* they seem to embody the theory's concerns. Yes, the Van Gogh sunflowers or the Brahms symphony or maybe Picasso's *Blue Bathers* will seem nicely to illustrate the expression theory of art, but you'd never pick a Mondrian canvas or a John Cage score to explore what expression theory claims art is. Conversely, to critique a work of art by appealing to a theory runs afoul of the same charge of selectivity: one picks a theory that seems "suitable" to the artwork in question, rather than any of the other available theories, and then wonders why the work seems somehow a bit tritely explained. One wouldn't engage in critical discourse, except for the most perverse reasons, by using, say, expression theory to interpret a Mondrian or Cage work; here formalist theories seem to have much more pull. But if we can pick and choose our theories as is convenient, what, exactly, have we learned from them about the works we use them to explore? Thus, aesthetics risks becoming boring, intellectually empty, and dreary, because the ways in which it connects theory and artwork don't really tell us anything new.

But there's another, more challenging way of doing aesthetics. Things change if we start with puzzle cases, cases that involve problems or dilemmas or quandaries, cases where we are not sure what to say or how to decide, or, more importantly, where we are not sure what theory to use. We cannot begin with theory; nor can we appeal to theory to "explain" works of art; instead, we have to get there the hard way, by teasing out the issues a puzzle case presents. These puzzle cases have much in common with the puzzle cases now very widely used in bioethics, legal ethics, business ethics, and other areas of applied professional ethics, and they share a feature in common: they don't come with easy solutions. This, of course, is just what makes them nonboring, intellectually full, and alive. (And, for those

skipping the discussion for adults, this is what makes them interesting to kids too.)

The Range of Puzzle Cases for Teaching Aesthetics

In addition to Case 1, *The Case of the Chartreuse Portrait*, consider several other cases that might be used in teaching aesthetics—either to adults or to children. Cases can be drawn from any area of the arts—painting, sculpture, photography, music, dance, poetry, fiction, drama, film, and so on, including areas often considered peripheral, such as gardens. But they will tend to fall into six general groups: cases about the nature of art; about beauty and aesthetic experience; about the meaning and interpretation of art; about creativity and fidelity in performance, replication, and reading; about the intersection of art and other values; and about the evaluation of art. Here is a sampler of cases in each of these areas, drawn from our casebook *Puzzles about Art*,[3] as they might be presented to children:

Group I: The Nature of Art

These cases all ask the question What is art? Is it representation? Is it the expression and communication of emotion, as expression theory insists? Is it the embodiment of a certain set of formal properties? Or is art just what is recognized as art by those who play roles in the world of art? For example:

Case 2. *Pile of Bricks*

Consider the following possibility, based on an exhibit at the Tate Gallery in 1976. A person already known, perhaps even famous, as a "minimalist" sculptor buys 120 bricks and, on the floor of a well-known art museum, arranges them in a rectangular pile, 2 bricks high, 6 across, and 10 lengthwise. He labels it *Pile of Bricks*. Across town, a bricklayer's assistant at a building site takes 120 bricks of the very same kind and arranges them in the very same way, wholly unaware of what has happened in the museum—he is just a tidy bricklayer's assistant. Can the first pile of bricks be a work of art while the second pile is not, even though the two piles are seemingly identical in all observable respects? Why, or why not?[4]

Group II. Cases about Beauty and Aesthetic Experience

Group II includes cases about beauty and whether beauty is "really real" or whether it is simply something "in the eye of the beholder," a function of the way a particular person sees something. The same questions can be raised about beauty's opposite, ugliness, as well as about the sublime, the fearsome, and other forms of aesthetic experience. For example:

Case 3: *Beautiful Plumage*

In many species of birds, the male has brilliant plumage, which

attracts females of the same species: think of the peacock, the China pheasant, the many varieties of parrot, and so on.

Is it correct to say that the male plumage is *beautiful* or that the female birds *find the plumage beautiful*? Can birds appreciate beauty? How would we go about trying to answer this question, if the only observation we can make is that the females are indeed attracted by the plumage? Is there human beauty versus bird beauty? If so, should all our references to beauty be of the form, beautiful to whom? Or are only human beings able to appreciate beauty and if so, what is it about human beings that gives them this distinction?[5]

Case 4. *Martian Marsks*

Let us suppose that we discover on Mars remnants of a culture that died long ago. Most of the things we find are completely alien to us; we cannot even guess how they were used. We have not deciphered the Martian language, and we know nothing about the physical appearance of the Martians, whose bodies must have completely disintegrated millions of years ago. One set of objects, however, is strikingly familiar to us: we find numerous items that look exactly like African masks. We name them Marsks. Again, we have no idea how these objects were made by the Martians and for what purpose.

Are the Marsks works of art? Are they beautiful? Are they meaningful? If yes, how? If not, are African masks works of art? Are they beautiful? Are they meaningful to us? After all, we know very little of the culture that produced them.[6]

Group III: Cases Concerning the Interpretation of Art

Among cases concerning the interpretation of art, a variety of issues arise: issues about the instructional and cognitive value of art (especially pressing in historical and descriptive works); about whether nonpictorial and nonverbal works, such as music and dance (as well as the *Chartreuse Portrait*) can have meaning or make statements; about the content of symbolic representations, and about truth.

Case 5. *Winterbranch*

The dancer and choreographer Merce Cunningham describes the reactions of different audiences to his piece *Winterbranch*: "We did the piece . . . some years ago in many different countries. In Sweden they said it was about race riots, in Germany they thought of concentration camps, in London they spoke of bombed cities, in Tokyo they said it was the atom bomb. A lady with us took care of the two children who were on the trip. She was the wife of a sea captain and said it looked like a shipwreck to her. Of course, it's about all of those and not about any of them, because I didn't have any of those experiences, but everybody was drawing on his experience, whereas I had simply made a piece which was involved with *falls*, the idea of bodies falling."

Is *Winterbranch* about race riots, concentration camps, bombed cities, shipwrecks, and the other human catastrophes in terms of which people see it?

Is it only about falls? Or is it not *about* anything? Is Cunningham's intention when he made the piece relevant to legitimate interpretation of the piece?[7]

Group IV. Cases about Creativity and Fidelity in Performance, Replication, and Reading

These cases, arising in those arts in which there is a model, script, or score for performance or where some other form of replication takes place, all focus on the relationship between the artist's actual product and the way it is actualized in performance or presentation. To what degree, if at all, may the singer "interpret" and thus alter the opera's score? What constitutes a conductor's "reading" of a work, and what is a "change," "liberty," "mistake," or other unwarranted departure in the symphony? What counts as a forgery? What exactly may/should a performing artist do and not do with and to the work being performed? Are these answers different for an actor, a dancer, a musician? What about a restorer of artworks that have been damaged? And so on.

Case 6. *Exact Replication*

As a result of advanced experimentation in molecular physics, a small manufacturing company announces that it has perfected a process by which any work of visual art can be replicated on a molecule-for-molecule basis. In painting, this process makes possible replication of an entire work, including canvas, frame, and all lower as well as exposed layers of pigment. No human guesswork (or error) is involved, and the finished replica is indistinguishable from the original to the most sophisticated visual, physical, and chemical analyses.

1. The company applies for a permit to produce one replica each of the *Mona Lisa* and ten other very well-known works at the Louvre as insurance, it says, against "natural disaster." The replicas are to be stored in a permanent underground vault and are not to be removed (or viewed) unless the originals are destroyed by calamities such as earthquake, vandalism, or nuclear war.
2. The company applies for a permit to produce 100 replicas of each of the above works to establish satellite museums in major cities and regional capitals throughout the world.
3. The company applies for a permit to produce unlimited replicas of the works, and announces that it plans to market the replicas in sundry and department store outlets for $14.95 each.

Would you grant any or all of the above permits? If you would grant (1) or (2), why not (3)?[8]

Group V. Cases about Conflicts between Art and Other Values

These cases involve conflicts between aesthetic and other values, including historical values, ethical values, religious values, economic values, and many others. Each poses what seems to be a quintessential apples-and-oranges problem, weighing the value of art against other important values,

where it is not clear there is any common scale by which they can be assessed.

Case 7. *The Fire in the Louvre*

The Louvre is on fire. You can save either the *Mona Lisa* or the injured guard who had been standing next to it—but not both.
 What should you do?[9]

Case 8. *Clothing Nudes*

Joe Brown, a noted sculptor of athletes who lived in Princeton, New Jersey, did a larger-than-life bronze of two gymnasts for the campus of Temple University, in Philadelphia. The male figure, dressed in shorts, both feet on the pedestal, holds the unclothed female high over his head in a dramatic handstand. Mr. Brown, in response to feminist complaints that the sexes are not treated equally in his work, replied that he had at first intended both figures to be unclothed, but a nude male at street level in a city would invite vandals to spray paint or decorate it in various ways, so he added the shorts.
 Should such issues affect the aesthetic qualities of artworks? Should the sculptor have left both figures unclothed? Both clothed? Clothed the female and left the male unclothed? Or do what he did? Are the shorts an artistic mistake?[10]

Case 9. *Photographing the Civil War*

Civil War photographer Matthew Brady frequently repositioned and rearranged bodies of dead soldiers and other objects in composing war scenes to be photographed. Is there anything about Brady's practice that should disturb us?[11]

Group VI. The Evaluation of Art

These cases all focus on critical judgment: the assessment of the valued properties of art and their relative worth. Noteworthy here are many disputes about public policies affecting art, including which works may be publicly displayed, supported, staged, and so on, as well as the critical judgments made by teachers, reviewers, program directors, funding agencies, and many others. Are critical judgments in any way objective, or are they (merely) expressions of individual taste?

Case 10. *Oh, No, Not that Same Story Again!*

Lord Byron criticized Shakespeare as follows: "Shakespeare's name, you may depend on it, stands absurdly too high and will go down. . . . He took all his plots from old novels, and threw their stories into dramatic shape, at as little expense of thought, as you or I could turn his plays back again into prose tales."[12]
 Is Shakespeare's use of familiar stories an aesthetic defect? Is Byron an undependable critic because his own poetic style and aesthetic values appear to be so different from Shakespeare's?[13]

Case 11. *Shooting Clay Pigeons*

Paul Ziff says that the sport of clay pigeon shooting is of "no aesthetic interest." The same is true, he says, of tiddlywinks, shuffleboard, archery, baseball, basketball, bicycling, bowling, canoeing, curling, golf, and fishing. But some sports do have distinct aesthetic aspects: gymnastics, ski-jumping, figure skating, high-diving, and bullfighting. He explains: "The relevant difference between the first and second group is this: form is a grading factor only for the second. How one does it counts in the second group of sports but not in the first. Sink the ball hit the target: that's what counts in the first group. Form doesn't. Hold the club any way one likes, look like a duffer: if one manages somehow to sink the ball expeditiously enough one may end up a champion."[14]

Is Ziff right in dividing sports up in this way? Should the judging of all sports be revised to take aesthetic aspects into account? Does a sport remain a sport when it is judged on aesthetic grounds?[15]

A Sample Discussion (for Adults and Older Children)[16]

To be sure, the discussion of such cases can be quite elaborate. Consider, for example, the following real-life case, based on an incident in the Vatican on May 21, 1972. A deranged young Hungarian-born Australian, claiming to be Jesus Christ, attacked Michelangelo's *Piéta* with a hammer, striking the statue fifteen times before he was dragged away.

Case 12. *The Damage to the Piéta*

A hammer-wielding attacker has damaged Michelangelo's *Piéta*, destroying the Madonna's nose, shattering her left arm, and chipping her eyelid and veil. You, as director of the Vatican Museum, must choose whether to preserve the sculpture as is or attempt to restore it. Suppose the options open to you are:
1. Do not alter the statue; do nothing to repair the damage other than clear away the rubble from the base of the statue.
2. Restore the nose, arm, eyelid, and veil as nearly as possible to their original appearance. You have available to you and your staff photographs and drawings of the *Piéta* made before the incident, as well as a plaster cast of the statue made forty years ago, and you can use a polyester resin to reaffix any salvageable fragments and to form a ground-marble plaster where fragments are too small to be used. If your work is successful, the new parts will look just like the old, and viewers will be unable to tell which parts have been restored.[17]

Forced to choose between these options, readers may find themselves torn. Those who pick option 1 will usually think that it would be wrong to substitute anything that wasn't Michelangelo's work, even if it might look a lot like the original, and that what is important is the authenticity of the piece: the fact that it is Michelangelo's work. They will point out that the

areas of damage could have been still larger and that if attempts were made to restore the work, there would be no limit in theory to replacing virtually the whole thing. But the statue would then be of no greater value than the plaster cast made forty years ago—an informative likeness, perhaps, but not Michelangelo's work.

Those who defend attempting to restore the *Piéta* (option 2) insist that the appearance of the work would suffer if it lacked the nose, parts of the eyelid and veil, and especially the left arm, which had been extended in a way integral to the balance of the composition, and that viewing it in this damaged state would interfere with one's aesthetic experience of the whole.[18] To be sure, they would admit, some important works, like the *Venus de Milo*, cannot be restored because we have no way of knowing what the original was like; but where we know the original and can replicate its appearance, it is imperative that we do so. They will grant that the restoration might be of poor quality, but claim that unless the job is botched, the statue will be of more profound aesthetic impact if some of its parts are not quite as they were than if they remain broken off.

In forced-choice puzzle cases such as this, what the reader must do, in analyzing and defending an answer to the practical problem the case poses, is to give a reasoned argument for the course of action he or she thinks appropriate. To be persuasive, reasons for a course of action must be based not just on immediate feelings, but must appeal to a more general principle. Thus a puzzle case like this requires articulation of the principle or principles that are held to make a given answer correct. Those who favor the purist policy 1, for instance, appeal to a principle of authenticity in art, that principle which is also appealed to when labelling forgeries and replicas inferior to their originals: this principle holds that it makes a difference whose work it is. Those who favor the integralist restoration policy 2 appeal to aestheticist principles about the appearance of an artwork and the importance of aesthetic experience: what is significant about a work of art is not so much who made it but how it looks.

Of course, many professional aestheticians would assent to *both* a principle of authenticity and a principle of aestheticism. This is what makes these puzzle cases dilemmatic: we want to have it not just one way or the other, but both ways at once. Yet a case like *The Damage to the Piéta* makes it clear that one cannot always have it both ways. This is so even if the case is revised to offer more sophisticated options that take account of both principles involved. Suppose, for instance, that there were two additional possibilities open to the museum director who must decide what to do with the damaged *Piéta*:

3. Working from photographs, drawings, and the plaster cast of the *Piéta* made prior to the incident, restore the nose, arm, eyelid, and veil to their original contours, but use a resin lighter (or darker) in

color than the original marble so that the viewer knows which portions have been restored.
4. Restore the damaged portions with a material that is visually indistinguishable from the original (i.e., follow option 2), but incorporate a tracer dye into the resin to permit X-ray identification of the restored portions.

If offered these two possibilities, many readers will again find themselves torn, though since both options 3 and 4 represent compromises, their discomfort may not be as intense as when they were faced with the choice between options 1 and 2. Nevertheless, the reasons they give for preferring 3 will still appeal primarily to the principle of authenticity and for 4 to aestheticist considerations. No solution permits them to have it both ways; either the statue no longer looks like the statue Michelangelo created, or some portions of what looks like the work are no longer his.

To resolve this case, then, one is forced not only to identify the principles to which appeal is made—these are usually stated as reasons in the explanations of why one course of action is to be preferred to another—but also to prioritize the principles that have been identified. Either authenticity gives way to aestheticist principles, or the other way around. The difference between those who pick 1 or 3 and those who pick 2 or 4 can be said to consist in a difference in the way they rank principles that are accepted by all. They feel the pull of both authenticity and of aestheticism as principles important in response to art, but assign them different weights relative to each other.

In turn, the way weights are assigned to competing aesthetic principles indicates basic allegiances to background aesthetic theories. Expression-based theories will give higher priority to authenticity, while formalist theories will give greater importance to the perceptual properties of the work. But different expression and formalist theories will try to tread this line in different ways, and it is here that prodding with a specific, forced-choice puzzle case makes the background aesthetic theory display, as it were, its true colors. Some theories even insist that there can be no intermediate principles at all. But if a theory is complete and consistent as an account of art, it should eventually decide hard cases such as these in one way or another, and if it is inadequate to do so, the theory will thus reveal itself to be in need of extension or repair. By using cases, then, we can identify and address difficulties within aesthetic theory itself and thus reveal the sources of confusion as well as illumination in what we think about art.

While the discussion here is conducted at a seemingly sophisticated academic level, virtually all the points brought out in the discussion of *The Damage to the Piéta* could be make in the slightly Socratic dialogue form used to explore issues in *The Case of the Chartreuse Portrait*. Alternatively, they could be presented in lecture format, in staged dialogue, or—perhaps best for classroom use—live discussion and debate among groups of children.

Adjusting Puzzle Cases to Age Levels

Older children may bring a substantial amount of background knowledge to the discussion of puzzle cases and may be fully capable of exploring all the cases presented here in their current form. For example, among the points of background knowledge they will probably bring to *The Case of the Chartreuse Portrait*, they will at least know something about portraiture, they will know what the Museum of Modern Art is, they will know that a painting (usually) has a title, they will know that paintings are painted by an artist, and so on. This is just to say that they have some familiarity with the world of art.

But for very young children, it may be that very little of this background knowledge of the art world is available. A young child, say, a kindergartner, first- or second-grader, may know only a few—or none—of the facts that are presupposed in *The Case of the Chartreuse Portrait*, for example, and yet still be able to see the puzzle in it. What the teacher does is to rephrase it, adjusting it to the appropriate age or grade level, by deleting any specialized background knowledge:

Case 1a. *The Case of the Chartreuse Picture*

> One day, Billy, your teacher says she wants to draw a picture of you. She takes a sheet of paper and covers the whole thing with chartreuse crayon (you know, that yellow-green color), and then she tacks it up on the board. Under it she writes, "This is a picture of Billy G." Would you be mad?

Nothing has changed in this case except that external references have been deleted; the case now fits entirely within the familiar world of the child. But the aesthetic issues are the same: What is a picture? How do you know what the person who drew the picture meant? and What can a picture say about something? Big language and elevated jargon aren't necessary to discuss these issues; even a kid can do it.

Adjusting cases to age levels in this way raises an additional issue that does not arise as clearly when such cases are presented to adults: this is the issue of developmental cognitive maturity. For example—though I know of no specific experimental data on which to base this claim—it's my hunch that children, especially younger ones, will at least initially gravitate toward certain sides in an issue, rather than others. For example, I'd guess that in Case 12, *The Damage to the Piéta*, a younger child would be more likely to adopt the formalist position (the view that however you put the sculpture back together, what's important is how it looks), rather than the purist position (the view that you mustn't add anything to the sculpture that isn't actually the work of Michelangelo). Perhaps (if this turns out to be true) a younger child's preference for the formalist view has to do with childhood experiences of breaking objects and having his or her parents

glue them back together ("now it's as good as new," the parents always say); or perhaps it betrays an innocence of the commercial art world that lionizes great artists; or perhaps other factors. Whatever the case, it may be that a teacher will have to work a little harder to get children at younger stages of cognitive maturity to see some sides of certain issues. This is still true, I think, even at the college level, where different types of students may gravitate toward different initial positions. For example, I notice in college-level discussions of Case 7, *The Fire in the Louvre*, that many older, often "nontraditional" students and many art majors want to rescue the *Mona Lisa*, while younger undergraduates and those who are not art majors are more likely to want to rescue the guard. But they are all capable of seeing the issue, once it is suggested to them, and they will work doggedly and argue vigorously with each other to try to figure it out.

Of course, puzzle cases can be adapted to higher levels as well. For instance, some more advanced students will respond to a reformulation of a case in the language of rights and obligations, or as issues at law:

Case 1b. *Suing over Chartreuse*

Al Meinbart paints the solid-chartreuse portrait of Daffodil Glurt and hangs it in the Museum of Modern Art. Have Daffodil's rights been violated? Ought she be able to sue for defamation of character? For violation of contract in sitting for a *portrait*? To what, exactly, did she agree when she decided to sit for the portrait, and what weight do her expectations have? Or are they outweighed by Meinbart's rights of expression, especially expression as an artist? Whose portrait is this, anyway?

And puzzle cases can be adapted to other audiences as well. The authors of *Puzzles about Art* have been particularly gratified by a couple of reports that using puzzle cases is especially effective in classroom situations with learning-disabled children who, though they may have difficulty with many verbal tasks, can readily see the puzzles at the core of these cases.

Regardless of the age or grade level of the students, it is clear what the challenge to the teacher is: once the case has been adapted to the appropriate age level and it is evident which way the student's initial response to the case runs, the teacher must then push and probe the puzzle by pointing out questions that highlight the other sides of the issue—or better still, invite open discussion among diverse students to explore it. The basic idea is to exacerbate the difficulty of the puzzle and then get the students to think it through as they try to resolve it. Which way particular discussions go depends, of course, on which direction the student initially takes; and this means, of course, that conversations with different students may be different, if they begin with differing intuitions about the case. The best conversations are the ones in which the teacher is able to respond to the students in a way that leads them along a path opposite to the one they initially took, or

lets them see that different students see the issue differently and, in doing so, reinforces the puzzle nature of the problem: how can a chartreuse patch *insult* someone, even if it certainly seems to do so? The ultimate objective is to make the students feel the tension inherent in the problem; they should want to have the *Piéta both* repaired *and* as Michelangelo carved it; they should want to rescue *both* the *Mona Lisa and* the guard. If they respond to these tensions, they will be doing the crucial intellectual work.

Of course, as in any area of philosophy, aesthetics is often a good deal more successful in posing questions than in reaching answers, and the child's simple world may be disturbed by leading him or her to ask questions neither he, she, nor the teacher can answer. But, of course, this discomfort is part of genuine education: aesthetic issues are not easy ones. After all, it is just this sort of questioning which may, ultimately, have profound effect on the way in which a future adult views, creates, and values art.

Finally, for dessert, since kids especially like things that are real, one can always serve them the actual version of the *Case of the Chartreuse Portrait*, the one on which the variations presented here are originally based:

Case 1c. *The Case of the Black-on-Black Portrait*

In 1957, the abstract expressionist painter Ad Reinhardt painted a portrait of Paris art dealer Iris Clert. The portrait is black on black, and it is titled "Portrait of Iris Clert." Clert was flattered. Should she have been?

This, of course, will serve as an exercise for both student and teacher.

NOTES

1. This case and some of the surrounding text come from my short piece "The Contributions of Aesthetics," in *Research Readings for Discipline-Based Art Education*, ed. Stephen Mark Dobbs (Reston, Va.: National Art Education Association, 1988), p. 27.
2. J. A. Passmore, "The Dreariness of Aesthetics," *Mind* 60, no. 239 (1951). Passmore denounced aesthetics' dullness, its pretentiousness, and the fact that it was "peculiarly unilluminating"; he had in mind the vapid abstractions and metaphysical hyperbole involved in "saying nothing in the most pretentious possible way." He also thought aesthetics wasn't in touch enough with the real world of the specific, different arts. Thus what he meant by "dreary" isn't all that I mean by "boring," but close.
3. All the cases provided in this section are from *Puzzles about Art: An Aesthetics Casebook*, by Margaret P. Battin, John Fisher, Ronald Moore, and Anita Silvers (New York: St. Martin's Press, 1989).
4. *Pile of Bricks* is based on Robert J. Semple, Jr., "Tate Gallery Buys Pile of Bricks—Or Is It Art?" *New York Times*, 20 February 1976, p. 31, and was contributed to *Puzzles about Art* by W. E. Kennick.
5. Case from *Puzzles about Art*, contributed by M. P. Battin.
6. Case from *Puzzles about Art*, contributed by Eddy Zemach.
7. Case from *Puzzles about Art*, contributed by Annette Barnes.
8. Case from *Puzzles about Art*, contributed by M. P. Battin.

9. Case from *Puzzles about Art*, contributed by M. P. Battin.
10. Case from *Puzzles about Art*, contributed by John Fisher.
11. Case from *Puzzles about Art*, contributed by M. P. Battin.
12. Bill Henderson, *Rotten Reviews: A Literary Companion* (Wainscott, N.Y.: Pushcart Press, 1986).
13. Case from *Puzzles about Art*, contributed by Anita Silvers.
14. Paul Ziff, *Antiaesthetics: An Appreciation of the Cow with the Subtile Nose* (Dordrecht, Netherlands: D. Reidel, 1984), pp. 62-63.
15. Case from *Puzzles about Art*, contributed by M. P. Battin.
16. The following section is taken from the Preface to *Puzzles about Art*, pp. vi-ix.
17. The *Piéta* case, from *Puzzles about Art*, is based on one by Mark Sagoff. He provides a defense of the purist response in "On Restoring and Reproducing Art," *Journal of Philosophy* 75, no. 9 (1978): 453-70.
18. A defense of the integralist response to the *Piéta* case is given by Michael Wreen, "The Restoration and Reproduction of Works of Art," *Dialogue* 24, no. 1 (1985): 91-100.

These remarks draw on my "What Can Aesthetics Contribute to a Young Person's Ability to Understand and Value Art?" presented at the Getty Seminar on the *Discipline-Based Art Education Monograph*, Scottsdale, Arizona, November 1985, which appeared as "The Contributions of Aesthetics" in *Research Readings for Discipline-Based Art Education*, ed. Stephen Mark Dobbs (Reston, Va.: The National Art Education Association, 1988); on "The Dreariness of Aesthetics (Continued), with a Remedy," *Journal of Aesthetic Education* vol. 20, no. 4 (Winter 1986); and on "Lessons from Ethics: Case-driven Aesthetics and Approaches to Theory," in *Aesthetic Distinction: Essays Presented to Göran Hermerén on his 50th Birthday*, ed. T. Anderberg, T. Nilstun, and I. Persson (Lund, Sweden: Lund University Press, 1988).

Museum Education and the Aesthetic Experience

KATHLEEN WALSH-PIPER

I recall my first visit to an art museum vividly. When I was a fourth grader on a school tour, our bus passed Johns Hopkins University (a name I recognized), then stopped at an imposing building. I clearly remember the docent halting our group on the stairs and saying, "Now we're going to see what you really came here to see—the mummy!" (I was relieved to learn that the trip had a purpose.) The mummy was OK; but then the docent began explaining an ancient floor mosaic which had been mounted on the wall. I remember being enthralled as she explained the mosaic. As I look back, I can't remember what it depicted, but I was intrigued by the idea that someone carefully made this picture out of tiny stones, that someone had such a beautiful handmade floor in his house so long ago, and that it had been saved for me to see. Part of my experience came from the warm sunlight that streamed across the muted colors of stones and the particular mood of "looking for fun" the tour had inspired.

At around the same age, I recall being powerfully impressed by a plate of sliced plums in our kitchen at home—purple skins with green centers and red skins with orange and yellow centers. I remember the same kind of feeling, a combination of interest and pleasure and curiosity, that to me defines the aesthetic experience. The moment is one of heightened attention to perception, which is what makes it both meaningful and memorable. These are the qualities that foster subsequent worthwhile reflection and, as Marcia Eaton explains in her essay, one crucial element of artistic activity is thinking about it.[1]

Within the discipline of aesthetics, the "aesthetic experience" is an inherently controversial notion, and my conception of it is but one of many. Even if any particular definition of this concept is less than certain, we *can* be certain that we all have aesthetic experiences, and that these experiences can play an enormously important role in our lives. The articulation of these

Kathleen Walsh-Piper is Head, Department of Teacher and School Programs at the National Gallery of Art. A former editor of *Art Museum News*, she is the author of *Teacher's Planning Guide to the Art Institute of Chicago*, the *Great Ideas Education Kit*, and a recent article in *PTA Today*.

experiences and their relationship to works of art are examined in the ongoing discourse of aesthetics, a reflective and self-conscious activity aimed fundamentally at enriching human existence by clarifying our thinking about such matters. Education, as the process of empowering students to appreciate, understand, and contribute to the world in as many ways as possible, should engage aesthetics wherever it involves itself with the "nature and components of aesthetic experience," in Eaton's phrase.

The Role of Art Museums

What is the role of art museums in aesthetic education? Whatever the quality of the works of art, one art museum tour cannot be expected to ensure that each of its participants will have an aesthetic experience. Nevertheless, although there are many ways of explaining, encouraging, and perhaps facilitating aesthetic experience in classrooms, homes, and communities, museums provide a unique resource, and hence a decided advantage in the cultivation of aesthetic experience: they provide a firsthand exposure to great works of art. Museums by their nature affirm the need to identify and contemplate works of art. The very existence of an institution devoted to collecting, preserving, exhibiting, researching, and interpreting works of art demonstrates the concept of "setting aside" an object for aesthetic contemplation (as a Chinese scholar might set aside for special delectation a rock chosen from nature). The aesthetic goals of a museum are often evident in its architecture. The building, whether a grand temple, a spare modern tower, or an intimate historical structure, is frequently designed to encourage a feeling of separateness from the everyday world, a place in which to marvel. This special sense of place puts the visitor in a reflective frame of mind. For children, the very atmosphere of a museum setting can establish an attitude toward *looking* as a special, separate activity. Teachers, docents, and other visitors model this behavior for them.

The objects in the museum present a wealth of symbols from many times and cultures. Exploring the meaning of works of art teaches the connection between art and broader symbol systems, between art and the fabric of life. But *all* of the objects (except for the building itself) in being "set aside" have also been removed from their original context. Can we understand a medieval altarpiece, an African mask, a Greek sculpture, or an Art Deco vase as did the people for whom these were living symbols? How can the museum make the object come alive? Opinions range from those of purists who believe that the object speaks for itself, to those of persons who reconstruct "period" rooms or wear costumes to help visitors imagine the context for a work. The tension between these opinions poses the challenge to curators, museum educators, and exhibit designers to help visitors think about different ways in which a thing may profitably be seen. The technology that allows us to show videos of African masks being "danced" may well help

us to explain their cultural role in a way no lecture or label would provide. The resulting problem of making the twentieth-century video equipment "disappear" in the gallery so as not to distract from the works of art is a new challenge for museums, as well as a good example of the philosophical problems inherent in the mission of retaining the contextual point of objects even while setting them aside for appreciation.

The Museum's Power to Transform Objects

Marcia Eaton refers to hand-pieced quilts as an example of functional objects that are seen anew in the museum setting.[2] Although textiles were being collected by American museums from their founding in the late nineteenth century, it was probably the social environment of the sixties, the "return to nature," that made museum visitors more interested in the pieced quilt. Eaton's questions of whether "the true experience of quilts is felt only in their proper context" and of "who benefits when quilts are hung in museums?" go to the heart of the matter. Even those who live with a quilt on their bed every day may not appreciate its design or its possibilities for resonant memories. By displaying the quilt "as an object to look at and think about" (a defining function of works of art) the museum makes an aesthetic choice and presents an aesthetic possibility. Objects such as quilts are a wonderful way of introducing children, most of whom have seen handmade quilts, to the idea of looking at ordinary objects for their extraordinary beauty, to understand how and why they were made, to learn about quilting bees, the social purposes and the associations of quilts. Everyday objects also help to connect the museum setting, which can be so intimidating, to the real world, thus making children more comfortable with the setting.

The recent dispute over whether the Smithsonian Institute should have allowed the designs for its most famous quilts to be reproduced by hand overseas to be sold in mass quantities in U.S. department stores and mail-order catalogs underlines another interpretive dilemma.[3] Do reproductions, which make works of art known to millions, detract from or enhance the experience of their originals? Since most discussion of works of art in classrooms involves reproductions of famous works and many schools have no access to museums, the question may be moot. But there is substantial agreement among experts that experience of the original work is important aesthetically. And the uniqueness of the art object is best taught firsthand during the museum visit.

Another challenge for museums is their role as the arbiter of beauty and aesthetic value—a role that is constantly both reinforced and challenged by our culture. Students should see a wide range of visual expressions in order to develop a critical base for making judgments and to develop their own imaginations.[4] Museums make aesthetic choices in everything they do,

from the arrangement of spaces, the choice of exhibitions, the arrangement and lighting of the works of art, to the design of furnishings and brochures. The most important choice is the selection of objects to be exhibited. This power to choose is a double-edged sword; choices could be said to entomb values and preserve cultural prejudices rather than to present examples of the best. Students should be made aware that every museum represents just one set of choices rather than a universal value system. Although many museums have encyclopedic collections providing an interpretation of the aesthetic sensibilities of many cultures, it is unrealistic to assume that one institution can represent all of humanity's efforts. Collections must always be seen as exemplifying one approach, while acknowledging at the same time that various other valid approaches also exist.

Within a set of choices lies a set of expectations. For example, it is practically universally acknowledged that *Mona Lisa* is one of the greatest paintings in the Western world. Yet my seventh-grade students in a suburban Midwest town couldn't accept it as a such. They felt she just wasn't beautiful, and thus the painting couldn't be great. They judged the work of art by the beauty of its subject and equated beauty with conventional modern standards of appearance. This provided a great opportunity to examine changing standards of beauty and to discover its relative nature, but also to reflect on the question of what makes a work of art. Must it be beautiful? Perhaps a good museum activity for this age group would be to find examples of objects they deem beautiful and ugly, to discuss why, and to consider why each object has been "set aside" in the museum, what it has to tell. To engage these young museum visitors in this way is not only to enhance their appreciation of the artworks they view; it is to plant seeds of aesthetic awareness that will grow to affect other areas of their lives.

Modern art is particularly difficult for those whose concept of art is limited to "masterpieces" or "old master paintings." For example, a number of people participating in the Getty focus group project at the National Gallery of Art questioned the authority of the museum to designate these works as "art" and felt that only the artist could explain these works. This raises the issues of who decides what constitutes a work of art and how best to interpret these works for the visitor. These issues, and others like them, are themselves important components of the broader perspective of inquiry in which young people may intelligently approach art. Young people *should* be asking themselves why these particular works are in the collection, who chose them, why, and so on.

Changing the Cultural Agenda

Another challenge for museum educators is that of giving proper scope to cultural diversity while acknowledging the impossibility of presenting a

collection that is all-inclusive. Students should see a wide range of visual expressions in order to develop a critical foundation for making judgments. The issue of presenting context and explaining an object's symbolism within a culture is particularly relevant here. Museums cannot change their collections overnight, but they can make a commitment to collection policies that allow for diversity within their specialty. For the museum educator it is important to examine the role of art as a record of experience and a response to the universal human condition and to draw parallels and contrasts with other cultures when possible. The museum's power to set aesthetic standards, even by decisions as seemingly minor as which objects to reproduce in postcards or slides, is one that requires a concomitant responsibility to encourage open interpretation and dialogue about the museum's collection.

Visitors may tend to assume that there is some magic formula to a museum's choice and arrangement of objects. One important role of the education staff within the museum is to help visitors to feel empowered to see and to choose, to relate the works of art to their own search for meaning. There is a delicate balance between giving enough information to make art more accessible and allowing learners their own response. Educational experiences should stimulate curiosity and imagination, while allowing for the sheer pleasure and delight in looking.

The Complex Gestalt of Aesthetic Experience

In *The Museum Experience*, John Falk explains that "the visitor's perception is highly contextual, including the personal, physical and social contexts. The visitor's experience must be seen as a whole, a gestalt."[5] He describes learning in the museum as a complex process that consolidates new information with existing constructs and expectations. His findings shed new light on why classroom preparation is important, since the work of art is not perceived in isolation, but as part of the total museum experience. For example, the museum setting can be so novel to a child that it causes anxiety or hampers learning. Falk cites a study that examined different styles of preparing students for a museum visit—a lesson stressing key concepts, another stressing process skills, and a third a child-centered approach that dealt with expectations as various as what they would see, what they could buy, where they could have lunch. This study showed that the child-centered approached worked best, because it allowed the students to be more relaxed and more focused during the actual tour.[6]

One of the greatest challenges for museum educators who work with visitors (and especially young visitors) is that even though they don't know the group, they need to create motivation to look and an active interchange of ideas "on the spot." An educational program must capture attention

quickly, create interest, and motivate inquiry. One of the biggest problems for educators in this regard is the elimination of distractions so that students can focus on the works of art. Falk describes four stages of visitor activity that museum educators should be aware of as they develop their teaching methodology: orientation, intensive looking, cruising (looking on their own), and leave-taking, an opportunity for social interaction with their peers.[7]

In order to allow for optimal development of the potential for aesthetic experience in the museum setting, the following are important considerations. The suggestions offered here apply to, and are meant to inform, the subsequent discussion of a museum tour.

1. Definitions or other accounts of what constitutes a work of art should be open to discussion, not assumed. A brief discussion of whether a particular piece can be considered a work of art, and why, is one way to begin. If there is a particularly controversial work, it should be included.

2. Educational programs should aim to increase and refine perception, both visually and conceptually, since the aesthetic experience is chiefly perception that is "attended to" or shared.

3. It is important to acknowledge that there is a *sense of wonder* that we sometimes experience yet find hard to explain, and that this particular combination of sentient, emotional, and cognitive awareness forms the basis of what we recognize as "aesthetic experience."

4. Standards for and definitions of beauty and ugliness are variable and subjective. A work of art does not necessarily have to be beautiful. Both beautiful and ugly objects can elicit important, positive aesthetic reactions from the viewer. A tour that takes up the question of beauty should consider a wide variety of objects and encourage open discussion.

5. No two individuals see the world the same way. Museum programs should be responsive to the variety of individual tastes, learning styles, and developmental stages.

6. Personal taste should be discussed, questioned, and encouraged.

7. Educational programs, whenever possible, should allow for questioning, choice, and the exploration of possibilities by participants, in order to encourage more open approaches to perceiving and thinking.

8. In disseminating and eliciting information about works of art, it is important to distinguish between facts and their interpretation and to show how interpretation helps to explain and justify our

appreciation for a work of art, allowing us to expand our horizons and increasing our potential for aesthetic experience.

9. To encourage the integration and enrichment of visual, verbal, and musical perception, education programs should combine art with writing, art with discussion, and art with music.

10. Educational programs should also explore connections between the world of art and the many worlds that surround it, including nature, human emotions, symbol systems, and, more broadly, culture.

Museum Tours

If a teacher is fortunate enough to have access to an art museum, a field trip provides a wonderful opportunity to view objects that have been chosen, valued, and set aside as art. This can be the most direct means of exposing students to the concepts of art and aesthetic experience. The value of the trip will be greatly enhanced if the teacher prepares the students by discussing in advance all of the "child factors" discussed above, as well as what a museum is, why people collect things, why they collect art, and what makes a work of art. The more open-ended this discussion can be, the better. The "case-study" method proposed in *Puzzles about Art*,[8] and discussed in Margaret Battin's essay in the present issue, provides a useful way to reach basic aesthetic considerations with even the youngest students. If students view in advance reproductions of the works they will see, they can also compare their experience of a reproduction to experiencing the real object. Of course, viewing "chosen" objects in advance could also be said to limit a student's openness, to define in advance "the best."

The most basic educational format for school children in art museums is the tour. Tours usually include an explanation of what the museum is, whom it belongs to, why the works of art are there, and a "sampling" of various works, often united by a common theme. However, it would be unusual for a tour to include a discussion of whether the objects the students will see are works of art. Any discussion of that issue would have to be quite extensive, requiring too much time to be incorporated into the usual basic tour. Such a discussion should, however, form an important part of the group's classroom preparation prior to the museum visit. A recent study has indicated that the three most important functions for a memorable museum visit are high personal involvement, connections to school learning, and repeat visits to the same museum.[9] In concluding this account of ways in which museum educators may foster aesthetic awareness in the museum setting, I will touch upon each of these functions in turn.

It is important for the teacher to choose the tour with the students' interests in mind and to be sensitive to their response while in the museum. A

docent or tour guide cannot be expected to "read" the students as success-fully as the teacher can. Although the choice of objects on a tour needs to be planned in advance, a guide should allow for the serendipity of personal encounter and, whenever possible, for student choices. I recall accompany-ing another teacher and her fifth grade class on a tour of a museum. As the docent led the class quietly through the galleries to a predetermined start-ing point, several students were distracted by an ancient Chinese village made of clay. The docent hurried the class on to the statue of Buddha atop a lotus blossom—without discussing the village. The village's appeal for chil-dren might well have been used creatively to involve the students on a per-sonal level with an ancient culture, enhancing their ability to appreciate the more the sculpture of Buddha. It would have affirmed the students' right to their own responses to stop and see the village. The alert teacher will be aware of his or her students' individual responses to both planned and un-planned elements of the tour, turning as many as possible into learning opportunities.

The choice of a theme for a tour can also teach certain points about aes-thetics. For example, a tour on American art might include colonial art, folk art, nineteenth-century landscapes, American Indian art, African-American art, and nonrepresentational art. This tour could provide a great opportu-nity for exploring the concepts of the relationship between art and culture, the fact that different cultures embrace different aesthetic values in every-day objects, and the idea of the existence of aesthetic influences from two very different cultures in one object. Or a tour on a theme such as Spanish art would trace aesthetic development within one culture, reflecting chang-ing tastes and changing times. Both tours should discuss the role of the art object, the function of the object, and the symbolic language of the culture.

Strategies for Encouraging Students' Personal Connections and Associations of Meaning with Art

Whatever the selection of works, the personal encounter with a work of art is central to the aesthetic experience. The orientation that allows a young visitor to relax, focus, and listen is important here. To involve the students personally, a school tour should be interactive, using inquiry and discus-sion to allow students to refine their visual acuity and to discover and ar-ticulate their own response to the work. Students need to be encouraged to take time to look at objects and to appreciate their formal qualities. "Seeing more" and gradually uncovering layers of meaning in order to develop per-ceptions is a primary goal. Aesthetic scanning of formal properties is one method, but there are many ways to motivate the young person to take the time to look carefully. Here is a sampling of strategies for building initial involvement.

1. Using inquiry sheets, instructors might ask students to describe what they see in a few selected objects, then share results.

2. In the course of various memory games, students might be invited to look at a work, then turn around and recall what they see, then finally look again together and see more.

3. A student might be asked to describe (orally or in writing) a work of art to a partner, who then is asked to embellish the description, and so on, involving as many in the group as is feasible.

These "warm-ups" promote personal viewing and encourage students to take a longer look. The docent or museum educator can also develop personal involvement by relating the objects to the viewer's life experience. For example, before looking at landscape paintings, viewers might be asked to talk about their own experiences with memorable landscapes they have actually seen or experienced through films or books. Describing these experiences will help students to understand why artists rendered their own views as they did. Some explanation of historical, narrative, symbolic, and functional factors may help locate the work in its cultural context. And at this point, young visitors should be ready to consider some of the fundamental aesthetic issues having to do with the interdependence of the artwork and its cultural setting, its utility function, and so on, as well as the interplay of aesthetic and extra-aesthetic values.

A group discussion to analyze formal properties and subject matter can be useful in enabling the student to read the visual language. Analyzing the use of color, line, shape, form, texture, space, and relationships among these elements should be done in terms of their expressive impact. Comparing and contrasting two works with a similar subject and material will provide students with the tools to discriminate between modes of expression and reinforce their understanding of formal properties. Discussion should include the process for creating the work, how the work was made, and materials chosen, so as to reveal the process of creation. Students need to learn that art is work, that imagination and innovation, as well as training and technique, play a role in creation.

Aesthetic experience must be *experienced*; it can't be talked or imagined into being. It is very important, therefore, that students be asked to reflect and share responses to the work. Exploring how visual experience is connected to other senses and how those sensations are altered and sometimes enriched by symbolism and context is a vital ingredient in deepening young people's understanding of the work of art. Separating and distinguishing emotional responses from facts, where possible, and explaining personal interpretations of the work will help youngsters develop self-awareness of the process of responding to a work of art, and this too is a vital component of the aesthetic experience. Sharing these responses will

make students aware of the multiplicity of responses and variance of taste. Through this sharing process, youngsters become aware that each viewer brings life experiences, personal values, and a unique perspective to a work of art, and that these factors form the basis of a fruitful collaboration between artist and audience. The museum educator's goal here should not be to affirm some response or responses as correct, but to help develop an awareness of the collaborative process through which artworks become what they are in a continuing stream of fresh, individual responses they inspire or provoke. Finally, the integration of seeing, analyzing, responding to, and valuing works of art should give students a sense of participation in active discovery that is intimately connected to the general increase of knowledge in their lives. If the students learn how to see reflectively and responsively, they may generalize and internalize this process, so that their enhanced perceptual abilities will enable them to see life, and not just museums, aesthetically.

All of this is a very tall order for one museum tour and a good argument that one museum tour is only the beginning, the briefest exposure to the possibilities of the museum. For this reason, many museums and schools are developing curriculum-coordinated multiple-visit tours aimed at encouraging students to become comfortable with the museum setting and to integrate looking at art with their own development. It should not be forgotten that the museum tour is a social experience, and recording it in photographs or in a group discussion back in the classroom can help to reinforce the learning that has taken place. Personal insight can be recorded in diary entries, drawings, or other assignments designed to ask the student to reflect on the museum experience. Memories of museum visits can be very powerful. The memory may be of a personal encounter with one work of art or the revelation of learning something new during the tour. It may be surprise at another's reaction to a work of art or a new insight into the visual language. Most importantly, practice in looking at and talking about works of art increases both our facility for and our understanding of the aesthetic experience.

The open-ended nature of interpreting and discussing art reflects the open-ended nature of man's search for meaning, recorded so poignantly in these objects. As Bruno Bettleheim states:

> This, then I believe to be the museum's greatest value to the child, irrespective of what a museum's content may be: to stimulate his imagination, to arouse his curiosity so that he wishes to penetrate ever more deeply the meaning of what he is exposed to in the museum, to give him a chance to admire in his own good time things which are beyond his ken, and, most of all, to give him a feeling of awe for the wonders of the world. Because a world that is not full of wonders is one hardly worth the effort of growing up in.[10]

NOTES

1. Marcia Eaton, "Philosophic Aesthetics: A Way of Knowing and Its Limits," this collection.
2. Ibid.
3. Jura Koncius, "The Quilts that Struck a Nerve," *Washington Post*, 19 March 1992, Home Section, p. 8.
4. Sandra Blakeslee points out that "neuroscientists have now found that the brain uses virtually identical pathways for seeing objects and for imagining them." "Seeing and Imagining: Clues to the Workings of the Mind's Eye," *New York Times*, Science Times, 3 August 1993, p. C7.
5. John Falk, *The Museum Experience* (Washington, D.C.: Whalesback Books, 1992), p. 83.
6. Ibid., pp. 31-33.
7. Ibid., pp. 59-61.
8. Margaret Battin, John Fisher, Ronald Moore, and Anita Silvers, *Puzzles about Art: An Aesthetics Casebook* (New York: St. Martin's, 1989).
9. Inez Wolins, Nina Jensen, and Robin Lizheimer, "School Children on Field Trips," *Journal of Museum Educators* 17 (Spring/Summer 1992).
10. Bruno Bettleheim, "Children, Curiosity, and Museum," *Children Today 9* (January/February 1980): 25.

A Is for Aesthetics: Alphabet Books and the Development of the Aesthetic in Children

CYNTHIA C. ROSTANKOWSKI

One of the earliest forms of "literature" traditionally made available to small children is the alphabet book. It is usually intended to instruct the child as well as to please him or her. The intent to please is evident in the fact that, besides the letter on the page, most alphabet books have illustrations, and some have a text which may include didactic content but which is sweetened by alliteration, end rhyme, any number of varieties of tropes, mnemonic devices, and sometimes pure silliness. The diversity among alphabet books in appearance, content, and intent make the genre one of the most creatively realized mainstays of early childhood education and literary experience. Indeed, among the surprisingly numerous collectors of children's books, alphabet books form a category that is highly prized chiefly because the freedom of expression they allow both illustrator and author is very conducive to aesthetic appeal. The literally "unlettered" children who provide the *raison d'être* for the alphabet book find within its pages an abundance of features that provoke aesthetic experience. In the humble alphabet book we find a natural vehicle for the cultivation of the aesthetic that is particularly useful as a means of focusing aesthetic experience in children.

Marcia Eaton has pointed out in her essay in this collection that aesthetic interest is present when people begin to engage in sustained questioning about art, particularly in terms of different sorts of awareness regarding qualities of the objects being considered. She provides a suggestive list of the kinds of questions that explore the realm of the aesthetic. Particularly in the presence of alphabet books, children are moved to consider precisely the sorts of questions she lists as indicative of the aesthetic. Awareness of colors or rhymes or specific sorts of representations are all involved in a child's interaction with the alphabet book. Why? Because alphabet books, perhaps more than any other sort of book created for children, are intended to be talked about and reflected on. They are specifically intended for the

Cynthia C. Rostankowski is a lecturer in philosophy at San Jose State University. She is the author of *Ethics: Theory and Practice* and Chair, Committee on Aesthetics and Young People, American Society for Aesthetics..

nonreading child, since if a child already knew how to read, he or she would not need to learn the alphabet. The child will either have someone who reads identify the letters for him or her and talk about the images and text with the child, or the child will look at the images in the book and reflect upon them. This instruction *cum* entertainment not only moves the child in the direction of the intended learning, but also cultivates in the child his or her ready engagement with the aesthetic.

Why ready engagement? Unlike other sorts of knowledge a person may come to have in his or her lifetime, to be able to engage in aesthetic awareness requires very little beyond what a toddler learns in beginning to talk: an awareness of the surrounding environment, for example, a knowledge of colors, shapes, and some common nouns for the things he or she may encounter, a sense of the difference between two- and three-dimensionality, an awareness of the sounds that are part of language and the world around one, for instance, animal sounds, birdsong, and the sounds of the spoken word as well as the willingness to interact with all of it in questioning, playful ways. In other areas of knowledge, much more by way of prior knowledge is required. For example, to interact with the world around one scientifically, one needs to know something about science, for example, scientific method, including inductive reasoning, a higher-level knowledge of the names of things, including perhaps their genus and species, appropriate technical terms, and so on. To interact with something historically, one needs to have a sense of history and an awareness of what has been deemed historically significant, for instance, facts, an awareness of the relevance of the past in relation to the present, documents and artifacts, and so forth. But to interact with something aesthetically does not require an extensive amount of prior knowledge the way scientific interaction or historical interaction does. One does not need to know anything about subjectivist or objectivist theories of beauty to be able to experience beauty. One does not need to possess an understanding of herpetology to enjoy the sounds of alliteration in saying "slithery silver snake" or to note and take pleasure in the undulating form of that snake colorfully represented on the page. Sometimes as a person acquires more specialized knowledge, he or she grows *less* likely to reflect or pay attention to things aesthetically in a direct and immediate sort of way. Those other aspects of knowledge often take precedence in one's consideration of one's environment, perhaps because as we grow up, we are more encouraged to take up more "grown-up" concerns.[1]

Curiously enough, however, the kinds of discourse and reflection on alphabet book texts engaged in by children and those who read to them actually require and depend upon an incorporation of features of aesthetic interest in order to further the more practical and didactic agenda of learning the alphabet. Most frequently, in order to advance an understanding of the relationship between a letter of the alphabet and its use, the text and

images rely upon alliteration to hit home the pronounced sound of the letter indicated. The simplest of such books have virtually no written text beyond the letter and the names of the objects illustrated. The letter "A" may be shown with an apple, ant, angel; "B" with a ball, basket, or banana, and so on, allowing the reader to emphasize the beginning sounds of the words and in so doing connect for the child the letter, its sound, and the words which begin with such sounds. In short order, a nonreading child will be able to do the same while looking at the images in the text alone, thus reinforcing the letter-sound connection by naming the images on the page. Images most appropriate for such teaching are those that are not readily able to be referred to by more than one name. Using a picture of a poodle to exemplify the beginning sound of the letter "P" may actually cause the child to become confused, or to misdirect the message of alliteration, since the child may simply read the poodle picture as "dog."

A more complex book incorporating text with end rhyme into the basic format described above often uses the text as a means of providing more alliterative examples of the letter being taught. An example of such a work can be found in *The Mother's Picture Alphabet*. The alliterative emphasis, clear from reading the text and seeing the illustrations, is reinforced in the beginning lines of text for almost all the letters represented in the book, for example, "I *begins* Infant, with fat cheeks and hands: . . ."[2] This format makes undeniably clear the alliterative intent throughout the work.

As further reinforcement of the letter-sound connection, mnemonic devices in the form of tropes such as metaphor and personification are sometimes used. Examples of personification are found in some of the very earliest alphabet books,[3] in which people are identified as the letter they represent and the images connected with the letter and text depict the people and their occupations or activities. The individual letters name the people, and who they are or what they do provides alliteration with that letter. Other alphabet books from this early period generally rely on personification also. The images, and also to some extent the text of these books, usually refer to children as the letters and are not as explicitly alliterative.[4] The alliteration may show up not only in the form of a noun, but just as likely as a verb or adjective.

An example of the use of personification in an alphabet book is found in *Twenty-Six Starlings Will Fly through Your Mind* by Barbara Wersba, in which almost all the letters are personified (a few are exemplified by metaphors). The attention paid to alliteration is more subtle and thus less significant as a memory enforcement. The strength of this book's use of personification and metaphor is to be found in the very striking descriptions that characterize the letters, and they can create powerful imagistic connections between themselves and the letter to which they refer. Consider the example of the letter "T":

T, with arms outstretched,
stands lonely
on all the beaches
of the world:
waiting for telegrams.

Give him a tambourine,
a trumpet and a timpani.
Let him make music
for the tide.[5]

To make clear the connection of the book with its role as alphabet-teaching medium, throughout the descriptive narrative reference is made to a child named Emily, to whom the book is addressed. Emily is encouraged to retain these fanciful and fabulous images of the letters in her memory in order to use them to remember the alphabet. Unlike the illustrations in the early books using personification, this work frequently presents the letters as if they were animate, acting and dressing as they are described in the text. Thus, personification and metaphor here occur both verbally and visually.

Perhaps the clearest and most sustained example of the use of verbal and visual tropes in an alphabet book is to be found in *Curious George Learns the Alphabet*[6] (fig. 1). The monkey George, mainstay of many books by H. A. Rey, is taught the alphabet by his friend, the man in the yellow hat. The man in the yellow hat gets out his sketch pad and easel and presents each

Fig. 1. From H. A. Rey, *Curious George Learns the Alphabet*. Reprinted by permission of Houghton Mifflin Company, Boston.

letter of the alphabet for George, both lower and upper case, and transforms each into someone or something the name of which begins with the letter being illustrated. Several other words beginning with the same letter are sprinkled though the passage referring to it.

Q
is a QUAIL.
QUAILS have short tails.

You must keep QUIET if you want to
watch QUAILS. They are quite shy.[7]

Each upper- and lower-case letter is represented as a metaphor, personification, or the occasional simile or symbol in this book, and each trope is represented both *verbally* and *visually*. Of course, this makes the book itself extremely long, and so it is broken up several times by George's activities, mischievous and otherwise. These "intermissions" make appropriate pausing points for the child who might find the whole upper- and lower-case alphabet presented in words and pictures a bit too much for one sitting.

We have considered thus far those alphabet books that clearly and accessibly provide a means of aesthetic awareness for children; but not all alphabet books are equally helpful, for a variety of reasons. In some cases, the books are too confusing. An example of such a book is *The Care Bears: The Baby Hugs Bear and Baby Tugs Bear Alphabet Book*.[8] This book *presumes* a knowledge of the letters of the alphabet, their appearance, and the sounds they represent in order for it to make sense to the child. Occasionally even locating the letters on the page when one knows them is difficult. The non-reading child looking at this work alone would very likely not realize the alphabet connection to the pictures on the page.

A contemporary, troubling example of the use of personification in an alphabet book is found in *The Z Was Zapped* by Chris Van Allsburg[9] (fig. 2).

Fig. 2. From Chris Van Allsburg, *The Z Was Zapped*. Reprinted by permission of Houghton Mifflin Company, Boston.

The book is described on the title page as a "Play in Twenty-Six Acts." It might more accurately be described as a horror alphabet for children, since the depictions of the letters are usually violent, frightening, peculiar, or otherwise distressing. Even the few images that are not of the distressing sort create the effect of tension while one turns the page to see what shocking image will follow. Although one might argue that Van Allsburg's images are really only of letters oddly depicted, the fact that the text of the book,

albeit ambiguously, personifies the letters, together with the ready tendency of small children to anthropomorphize inanimate objects, makes this alphabet book a problematic one. While the method that describes the approach to teaching most often used in alphabet books is positive reinforcement, one might surmise that Van Allsburg wished to use its alternative in his work. There is no question that children tend to remember things that frighten them.

Sometimes, however, alphabet books are not really intended for their projected audience. The Van Allsburg alphabet discussed above may be such a book. For older children who are better able to distance themselves from the fearfulness of the images, contemplation of horrible images that are beautifully rendered would be a fine source of discussion concerning the relation between the beautiful and the horrible, or whether a thing or image could be both beautiful and horrible at the same time.[10]

An entire series of alphabet books that may be useful in aesthetic education, but not for prereaders, has been produced by Florence Cassen Mayers,[11] with each book in the series utilizing images and objects from the collection of a different famous museum. While the images reproduced are beautiful, of the six books in the series only one contains a number of images immediately recognizable to the prereader, and often the images are identified by nouns beginning with letters other than those under which a young child would be likely to identify the image. For example, in *ABC: Museum of Fine Arts, Boston*, under the letter "Y" is the painting by the nineteenth-century American artist Jefferson Gauntt entitled *Two Children*. The word printed at the bottom of the page to identify the image according to its alphabetical listing is "youngsters." The other alphabet books in the series are challenging even to the well-educated adult. One might reasonably surmise that not many can identify the Senegalese kora, or the Swedish nyckelharpa, both found in *ABC: Musical Instruments from the Metropolitan Museum of Art*. Virtually any alphabet book that offers an alphabet within a certain classification of things is probably not accessible to the young child. Such books presume specialized knowledge in some area, such as the realm of transportation, birds of the world, or Egyptology. Furthermore, such knowledge may often preclude or at least overshadow the aesthetic focus that is otherwise amply present in alphabet books as they have usually been conceived. These are more like books of specialized trivia, alphabetized.

Other alphabet books that tend to be unhelpful aesthetically are those that make use of the alphabet format but focus on other agendas. One such blatant example is *The Bible Read-to-Me ABC Book*.[12] In this book, the intent is to provide snippets of stories from the Bible, with little significant connection with the alphabet or the images that accompany the text. In many cases, the Bible story snippets are so incomplete as to be confusing, but the probable intent is to send the reader to the Bible to look up and read the rest of the story. Specific biblical text references are found on every page.

Historically, the connection between letter and text or letter and image in alphabet books was fairly clear. As has been shown in some of the examples from early alphabet books offered above, the relationship between letter and the means used to illustrate it or reinforce it was usually readily understandable, as one might expect in books for the very young. Strangely and interestingly enough, this is not always so today. Even more strangely and interestingly, we are not always aware of why this is so. The most often-used locution in alphabet books to connect the letter with the alliterative image is "is for" as in: "A *is for* apple." We are all so familiar with this locution that we never think about its meaning, but if we do think about it, we will quickly become perplexed. Nowhere in the *Complete Oxford English Dictionary* can such a locution be found. Furthermore, grammatically, it is usually incorrect for a copula to take a preposition.[13] What might be going on here? I would like to suggest two possibilities, neither of which provides a directly verifiable solution to the linguistic problem, but both of which at least throw some light on the semantics of the phrase in question.

In some contexts, the word "for" means "representative of" or "representing," as in "The Cabinet member *was* there *for* the President." The use of "is for" may be an elliptical way of stating the same intent of meaning, with the "there" having dropped out over time and usage. In some sense the first letter of a word represents the word, and it rather explicitly does so when the first letter of a word is the initial of a proper name. Granted, most nouns in alphabet books are not proper nouns, but it is the initial letter and its sound that is most often significant in the typical alphabet book format. This interpretation is perhaps the closest to our typical way of explaining the "is for," namely, it means "stands for."

Another case can be made that relies more on the origins of the alphabet book in the distant past. As indicated earlier, we have every reason to think that alphabet rhymes in children's oral tradition preexisted their written and published counterparts by centuries. It is also widely known by scholars of old texts in many traditions that when a text is copied it is often changed slightly in the copying. The *A Is an Archer* text is an example of this. In one version, "B was a Butcher, and kept a great dog."[14] In another version, "B was a Butcher and kept a Bull-dog,"[15] and in yet a third version, "B was a Blind-man, and led by a Dog."[16] Since we can see exemplified by these three variations of the same alphabet rhyme verse the kinds of changes that occur with the nouns in the verse, it is plausible to suppose that something similar happened with the words used to link or modify the nouns. Our preposition "for" has several linguistic precursors that were spelled somewhat differently from one another. The words "fore" and "afore" have many meanings, some of which are similar to the meanings of "for" and some of which are not. According to the *OED*, "afore" may mean among other things "in front of." In fact, it is not so difficult to imagine that at some long-ago time, the locution used in the phrasing of the relationship

between a letter and the word which begins with it might have been "A *afore* apple." Since the formulation is no longer current, one might imagine a gradual change over time to a formulation which rather *sounds* like the antiquated form, but which *looks* like the form with which we have come to be familiar, namely "A *is for* apple." The use of "afore" is perhaps also given some credence when we look at the locution used in the work discussed previously from 1862, *The Mother's Picture Alphabet*. As we noted in that text, the word most often used to relate the letter of the alphabet with its alliterative word is "begins" as in "I *begins* Infant . . ." The sense of this verb approximates that of the antiquated preposition "afore."

There remains one aspect of alphabet books, and children's literature in general, which is a powerful draw to a child and, at the same time, a useful tool for learning, and that is the realm of silliness. Children readily engage in silly activities of any sort, and it is useful to be able to involve that aspect of the aesthetic in discussions with children, if for no other reason (and of course there are others) than to make clear to children that what is intellectually stimulating and significant can be fun, too. Two authors who have incorporated high-order silliness in their alphabet books are Edward Lear and Dr. Seuss. These authors use nonsense as the content of their alliterative rhymes, approximating the sort of language play that children often engage in for the sake of the amusing sounds they may produce. Edward Lear[17] was a master of nonsense and used it not only in his alphabet books, of which there were several, but also in most of his other writings for children, which caused him to be immensely popular among them. Consider an example from one of his alphabet books:

> E was once a little eel.
> Eely,
> Weely,
> Peely,
> Eely,
> Twirly, tweely,
> Little eel![18]

Not only do we find alliteration and end rhyme in this text, but also the repetition of the "ee" sound throughout the verse, to bring home the experience of that sound to the child. Some of the other verses rely instead on charming connections made with the alliterative word and the qualities the object picked out by it might possess. All in all, the work tends to generate calls for repeated readings because of the amusement it calls forth in the child. Also in keeping with his own tendency toward silliness, *Dr. Seuss's ABC*[19] exemplifies the qualities usually found in the works by Theodor S. Geisel, such as outrageous images and irreverent behavior all melded together in an alliterative and rhyming text. The flamboyance of Dr. Seuss is very appealing to many children, and his alphabet book is no exception.

What conclusion might one draw from all of this? Alphabet books may offer a child a purity of aesthetic experience unencumbered by the complexity of specific realms of knowledge in life, or even the complexity of a story. Anita Silvers, in her essay in this collection, refers to this untutored and unencumbered state as "the innocent eye." While Silvers argues that even school-age children (not to mention adults) lack a truly innocent eye,[20] the extent to which preschool children would be able to incorporate most of the cultural messages about art seems very limited, thus allowing a very close approximation of pure response in a situation lacking much by way of external attitudinal guidance about art and the aesthetic. Thus, by virtue of the lack of content over and above the alphabet and what might be included by way of images and verse to make it appealing and pleasing, the eye (or ear, for that matter) is assisted in retaining its innocent state. The less additional cognitive information the better to facilitate an experience of form, color, rhyming sounds, that is, the aesthetically noteworthy components of the alphabet book for the very young child.

For the older child, some of the remarkably beautiful but more visually sophisticated alphabet books can be helpful in focusing on aesthetic properties of an image and allowing that aesthetic focus to remain unconfused with other aspects of children's literature that might be distracting. Some examples of such books might be *Gretchen's ABC*[21] and *Anno's Alphabet*. *Gretchen's ABC* is free of all text, but for a small lower-case letter at the right-hand corner of each page. Sometimes the letter actually serves as a clue to help the viewer figure out what the illustration is an image *of*. This book is the work of a well-known artist and illustrator and moves the viewer to relate to the image on the page as lines, shapes, and colors in intriguing and pleasing arrangements, and only as images of things secondarily. Another visually pleasing book which is text-free is *Anno's Alphabet*.[22] This book may provide a ready lead-in to considering the works of Escher, or other works involving *trompe l'oeil* or illusionism, since the images of letters in this book all incorporate illusionistic and impossible elements.

The alphabet book can offer a path in the aesthetic education of a child that can be instructive and pleasing on various levels of awareness, depending on the book and the maturity of the child. The many creative responses to so apparently simple an undertaking makes the path one that is well worth exploring.

NOTES

1. This is itself a problem of some significance, not only in that it casts a certain negative veil over the aesthetic, but also because it contributes to the view that aesthetic education is unimportant, hence is the appropriate target of budget cuts, hence should not be taken seriously, and so on.

2. *The Mother's Picture Alphabet* (London: S. W. Patridge, 1862; repr. New York: Dover Publications, 1974). Italics mine.

3. The earliest alphabet book I have seen is reproduced in *A Nursery Companion,* by Iona and Peter Opie (New York: Oxford University Press, 1980). The book is called *A Was an Archer,* dates from 1819, and was published by John Harris. It was an alphabet rhyme with pictures. The rhyme certainly preexisted the published book, since an almost identical version can be found in print circa 1710, according to Eric Quayle, *Early Children's Books: A Collector's Guide* (London: David & Charles Publishers, Ltd., 1983). There is no question that children used hornbooks for the memorization of the alphabet centuries before, but alphabet books as we know them have their earliest examples dating back to 1538, a little more than fifty years after William Caxton printed the first children's book.

4. The two books to which I refer here are *Nursery Novelties* and *The History of an Apple Pie Written by Z,* both published by John Harris in the first quarter of the nineteenth century.

5. From Barbara Wersba, *Twenty-Six Starlings Will Fly through Your Mind,* illustrated by David Palladini (New York: Harper & Row, 1980).

6. H. A. Rey, *Curious George Learns the Alphabet* (Boston: Houghton Mifflin; copyright 1963 by H. A. Rey, renewed 1991 by Margaret Rey, assigned to Houghton Mifflin 1993).

7. Ibid., p. 48.

8. Phyllis Fair Cowell, *The Care Bears: The Baby Hugs Bear and the Baby Tugs Bear Alphabet Book,* illustrated by Tom Cooke (United States: Parker Brothers, 1984).

9. Chris Van Allsburg, *The Z Was Zapped* (Boston: Houghton Mifflin, 1987; copyright by Chris Van Allsburg 1987).

10. The relation between the beautiful and the horrible is one which has fascinated aestheticians since antiquity. Aristotle treats the matter in the *Poetics,* Book XIV, by discussing how the rendering of horrible events (i.e., events that we pity and fear) in a tragedy can nonetheless allow the audience to experience the beauty of the work and take pleasure therein while viewing it. A more contemporary treatment is offered by Guy Sircello in *A New Theory of Beauty* (Princeton, N.J.: Princeton University Press, 1975), where he distinguishes between something that is "grotesque, deformed or obscene" and portrayals or depictions of such a thing which can be done with "skill, imaginativeness, and vividness," hence making it aesthetically pleasing in that regard.

11. All are published by Harry N. Abrams, Inc., New York, 1988.

12. Joy MacKenzie, *The Bible Read-to-Me ABC Book,* illustrated by Kathleen Bullock (Elgin, Ill.: David C. Cook Publishing, 1988).

13. There are instances to the contrary, however. Occasionally "for" means "in favor of" or "in support of," and in such cases one can unambiguously combine the two, for instance, "She *is for* the Democrat in this election"; but this is not the sense of "is for" that turns up in the alphabet books.

14. This is the version found in *A Nursery Companion* by the Opies, originally published in 1819, which was discussed earlier in this essay.

15. This version is found in *The Big Book of Nursery Rhymes,* ed. Walter Jerrold (New York: Portland House, 1987).

16. According to Quayle in *Early Children's Books: A Collector's Guide,* this version of the rhyme is contained in *A Little Book for Little Children,* published about 1710 by 'T.W.' and "sold at the Ring in Little Britain, a district of central London where many booksellers had their stalls," p. 112.

17. Born in London in 1812 and died in San Remo, Italy, in 1888. He was an illustrator and author of children's books.

18. This verse is to be found in *An Edward Lear Alphabet* (New York: Mulberry Books, 1983). The original printing of this book is not listed in the contemporary printing.

19. *Dr. Seuss's ABC* (New York: Random House, 1963).

20. This is so, she argues, because of the stories and histories about art and artists which are common knowledge within a culture and which influence and instruct one's ways of thinking and acting regarding art.
21. Gretchen Dow Simpson, *Gretchen's ABC* (New York: Harper Collins, 1991).
22. Mitsumasa Anno, *Anno's Alphabet* (New York: Thomas Y. Crowell, 1975).